ILLUSTRATION

WITHDRAWN

ROCKPORT
PUBLISHERS

First published in the United States of America by:
Rockport Publishers, Inc.
33 Commercial Street
Gloucester, Massachusetts 01930-5089
Telephone: (978) 282-9590
Fax: (978) 283-2742

ISBN 1-56496-246-6

10 9 8 7 6 5 4 3 2

Layout: Sara Day
Cover Photographs: (*clockwise from top left*)
 p. 49; 45; Jacqueline Comstock;
 p. 4; Max Studio

Printed in China

Introduction

The art of illustration includes such a tremendous range of mediums and applications that it is difficult, if not impossible, to produce a collection that showcases the best. The texture and tone from one illustration to the next is so varied, due to the versatility and individuality of the different mediums and the different artists, that it is difficult to compile a collection of work so seemingly unrelated.

Our new Design Library *volume,* Illustration, *accomplishes this task brilliantly. Selected from the Rockport archives containing thousands of illustrations from the top illustrators from around the world, this collection presents finished work in all mediums, including watercolor, colored pencil, mixed media, and computer generated and manipulated illustration. Architectural illustrators, spot illustrators, commercial illustrators and fine art illustrators are all presented here, in a single, unique and affordable volume.*

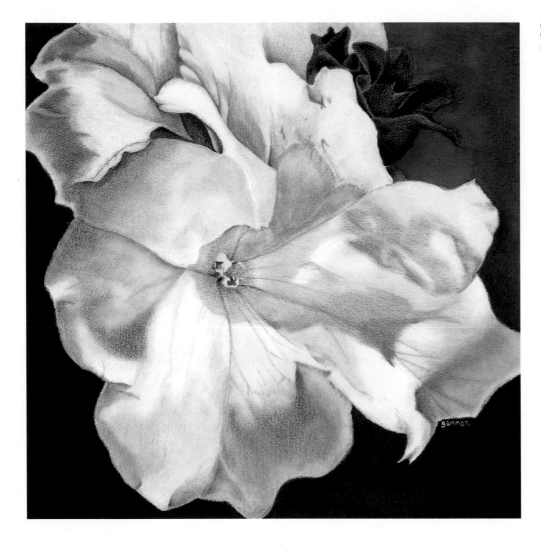

CLAUDETTE GAMMON
WHITE IMAGE (*LEFT*) 26 $\frac{1}{2}$" x 27"
SHELF LIFE (*BELOW*) 20 $\frac{1}{2}$" x 48 $\frac{1}{2}$"

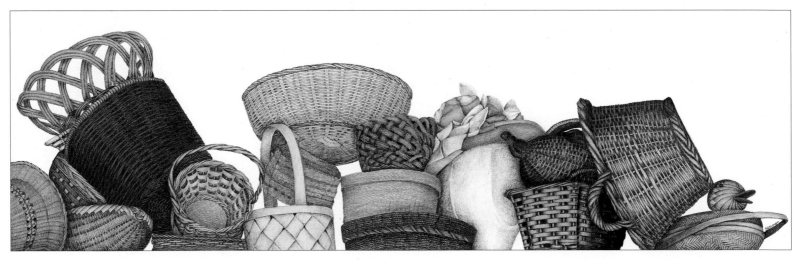

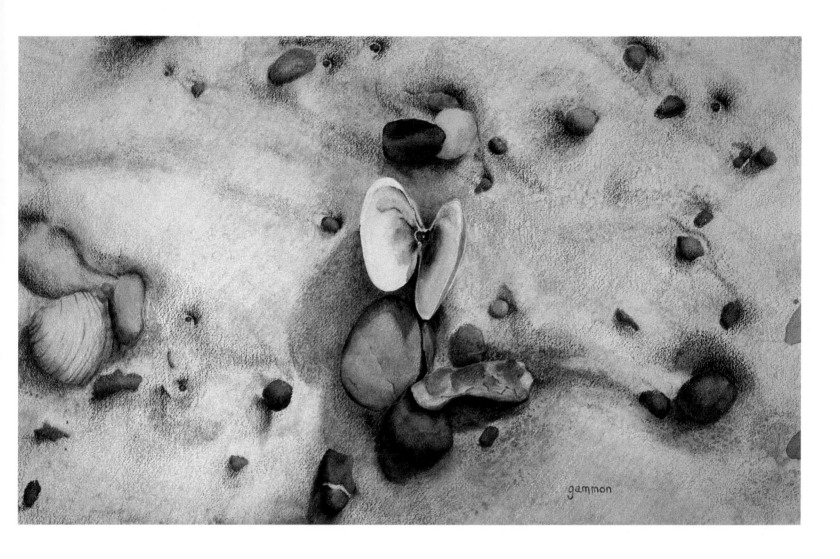

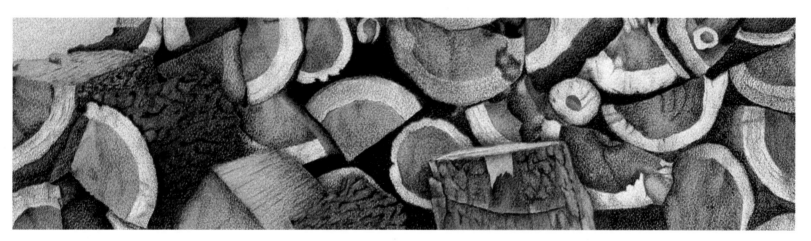

CLAUDETTE GAMMON
UNSEEN TREASURES (*TOP*) 20 ½" x 28"
DRYING TIME (*BOTTOM*) 15" x 38 ½"

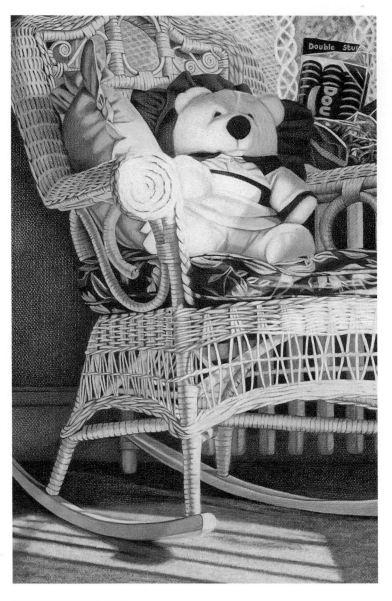

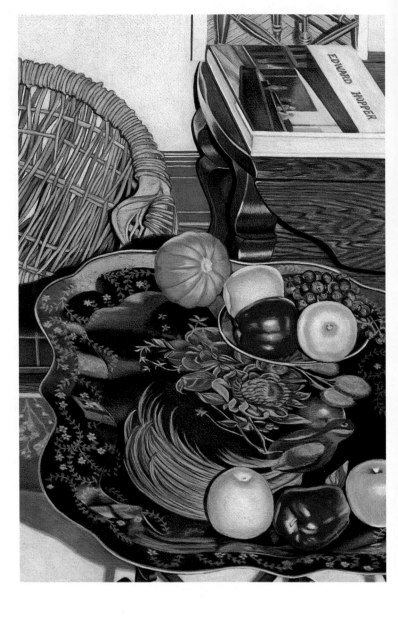

RONNIE KANTOR WADLER
OREOS (*LEFT*)
BASKET AND FRUIT (*RIGHT*)

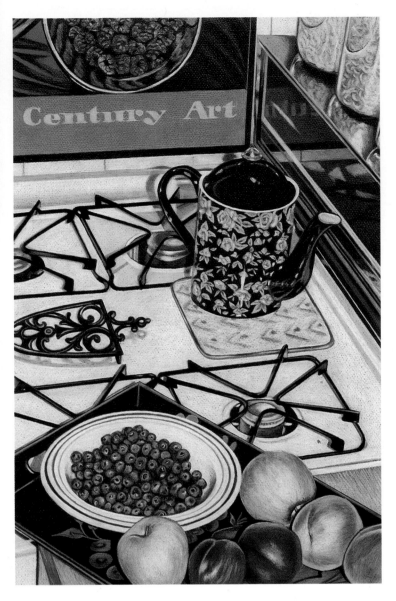

RONNIE KANTOR WADLER
Blueberries

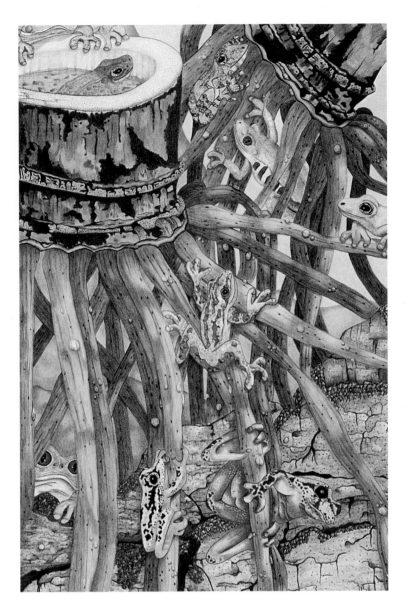

RHONDA FARFAN
Crossroads II 18" x 30"

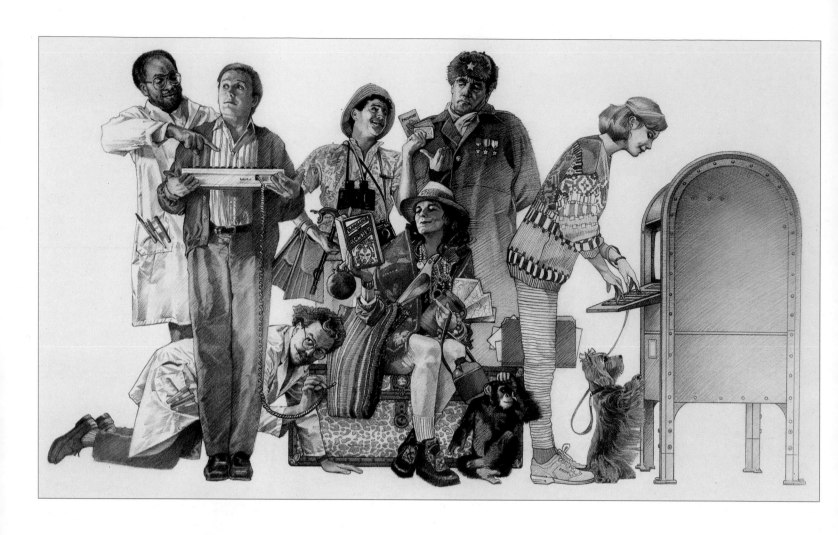

LINDA FENNIMORE
CLIENT: COMPUSERVE (*ABOVE*)

(*LEFT AND FACING PAGE*)
PORTFOLIO PIECES

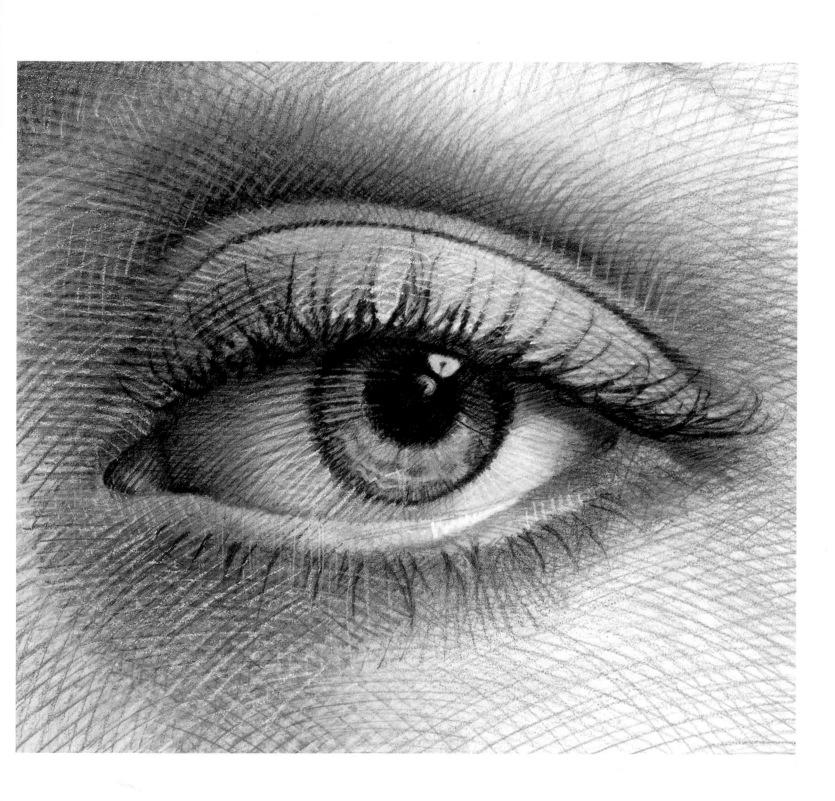

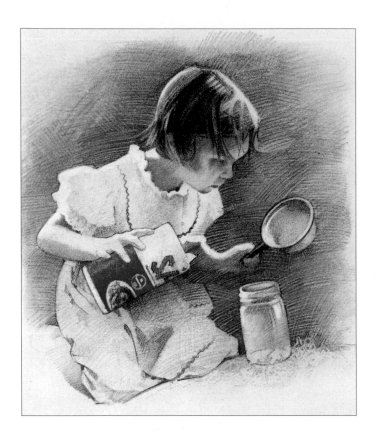

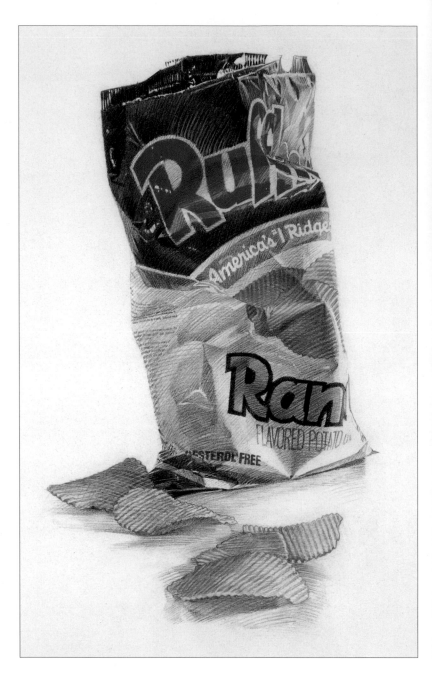

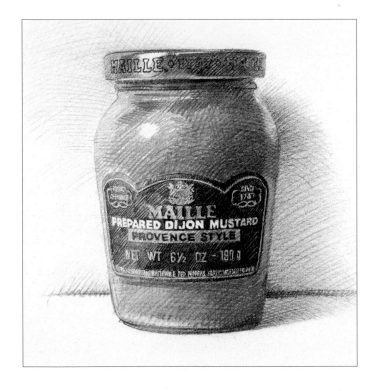

LINDA FENNIMORE
(*FACING PAGES*)
PORTFOLIO PIECES

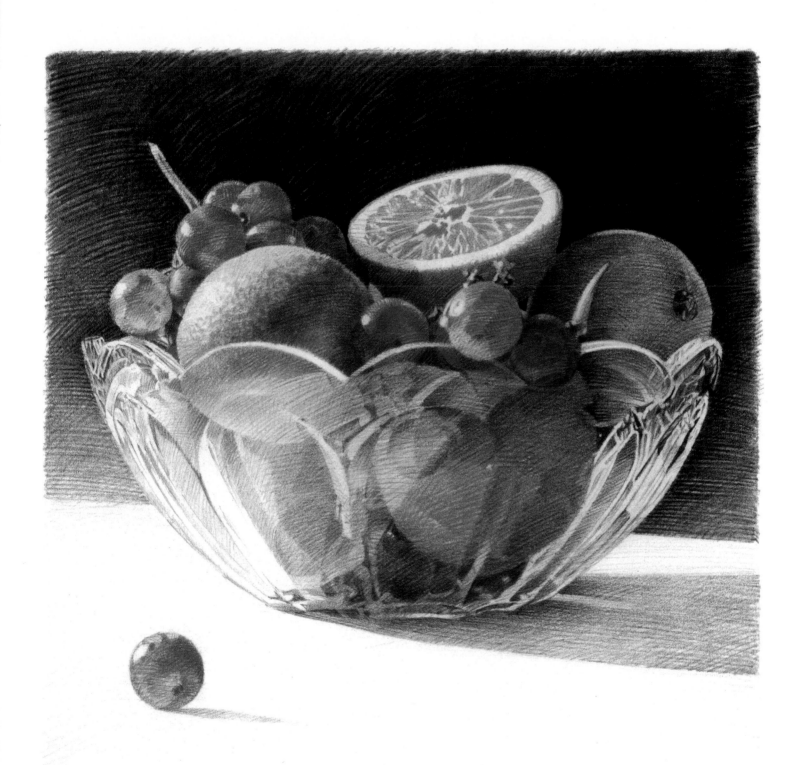

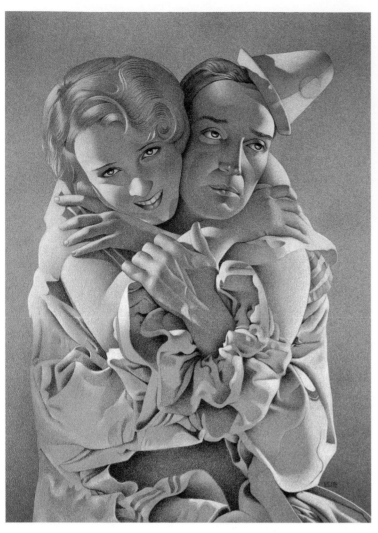

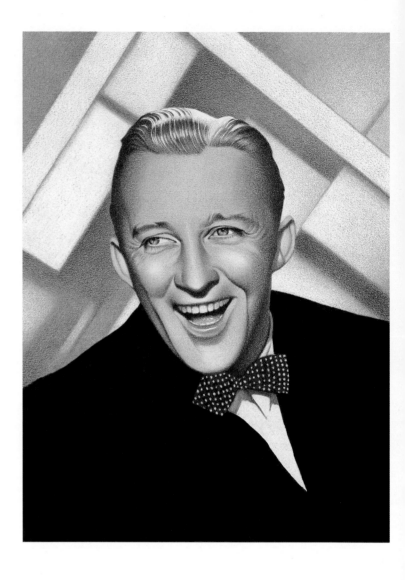

BILL NELSON
JOY AND PATHOS (*ABOVE*)
BING (*RIGHT*)

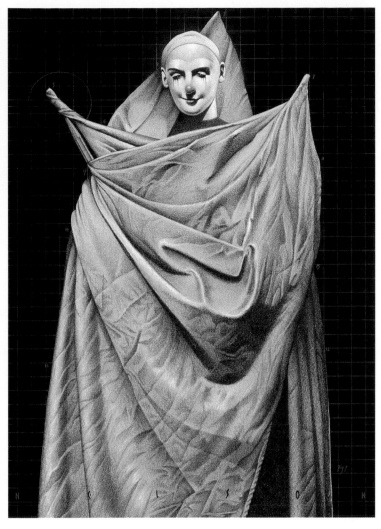

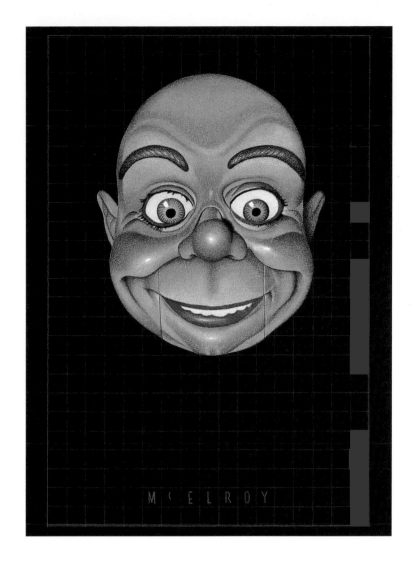

BILL NELSON
Draped Figure No. 1 (ABOVE)
Ollie (RIGHT)

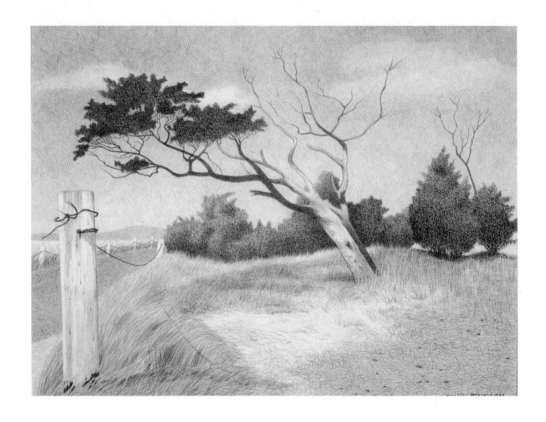

MICHAEL PETRINGA
GONE FOR A SWIM (*LEFT*) 14" x 10"
ROAD TO THE BEACH (*BELOW*) 14" x 11"

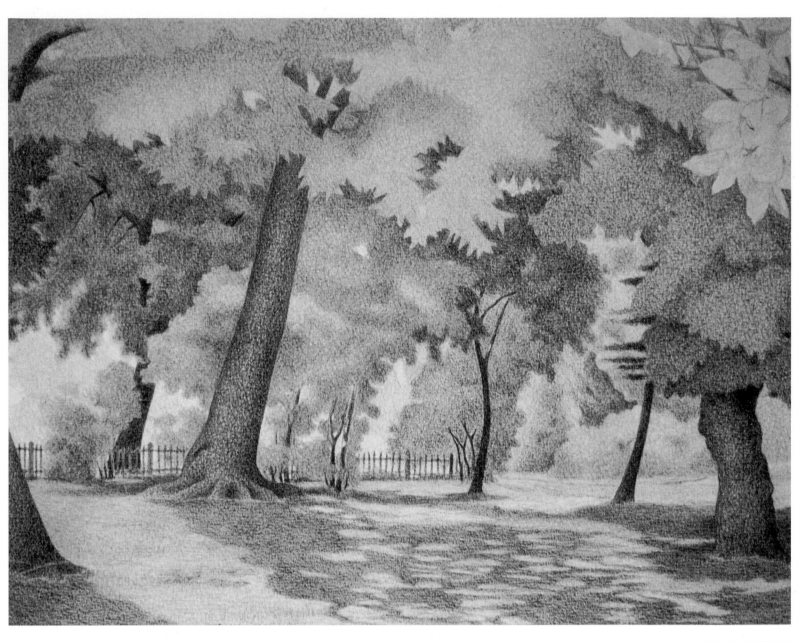

MICHAEL PETRINGA
TREES AT HOLLAND PARK 13 ½" x 10"

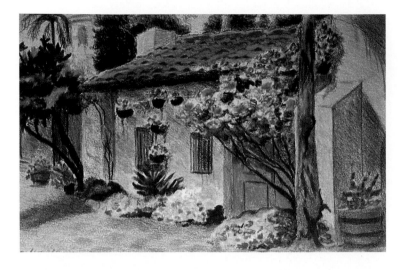

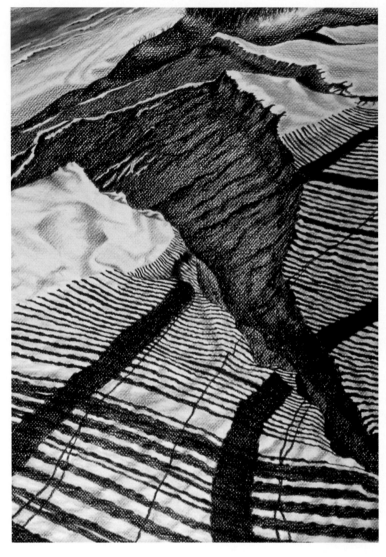

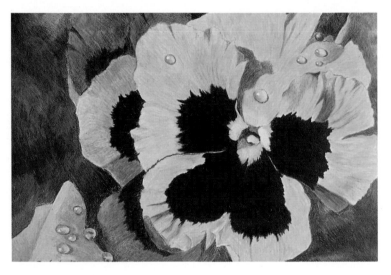

VIRGINIA BARBER
THE BLUE DOOR (*ABOVE*) 6" x 8"
PANSY FACE (*BELOW*) 8" x 11"

KRISTY A. KUTCH
DUNE RAVINE

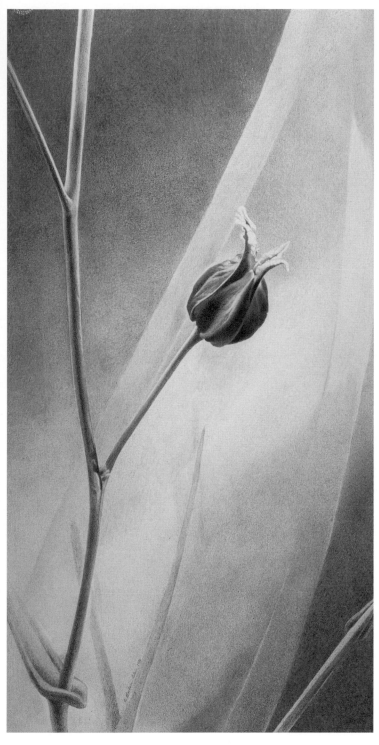

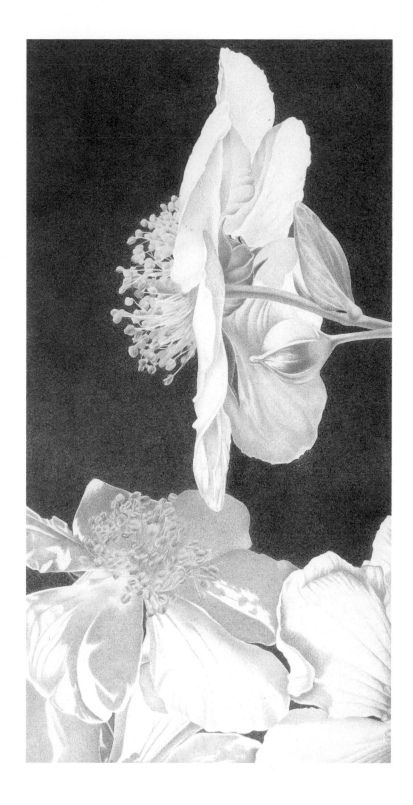

BARBARA ADAIR
Black Jewel Plant (*ABOVE*) 23" x 14"
Bush Anemone (*RIGHT*) 23" x 11"

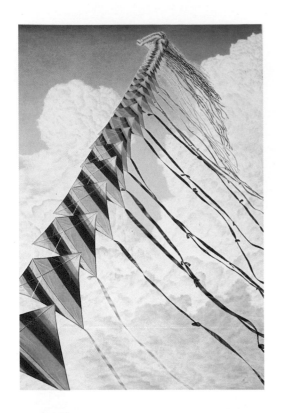

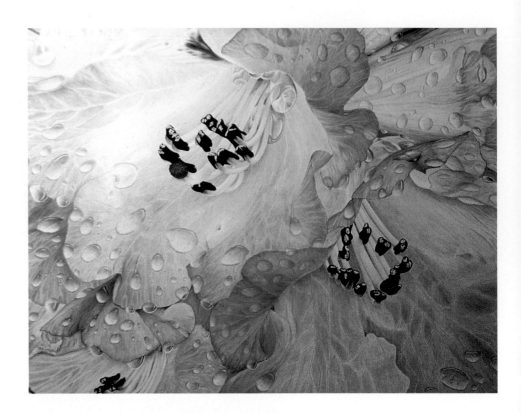

GARY GREENE
(*CLOCKWISE FROM TOP LEFT*)
KITES 25" x 35"
RHODODENDRONS 40" x 32"
PINWHEELS 19" x 24"

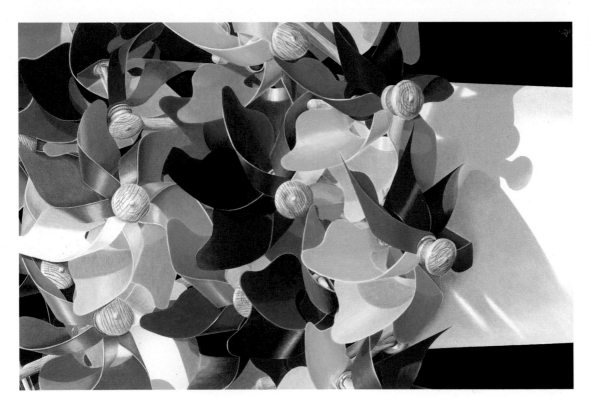

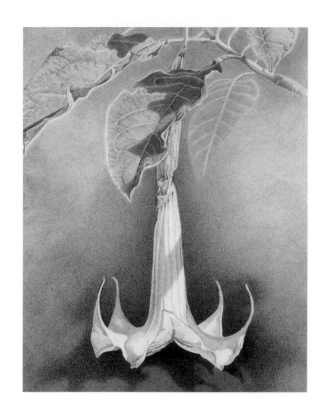

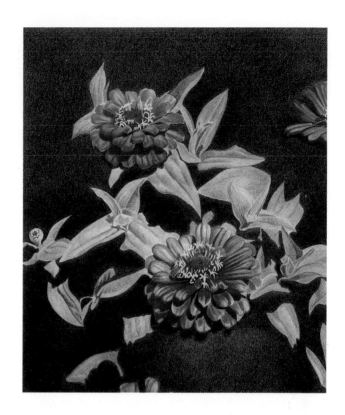

KATHARINE FLYNN
(*CLOCKWISE FROM TOP LEFT*)
ANGELS TRUMPET 17" x 14"
ZINNIA 17" x 14"
HAWAIIAN HIBISCUS 19" x 24"

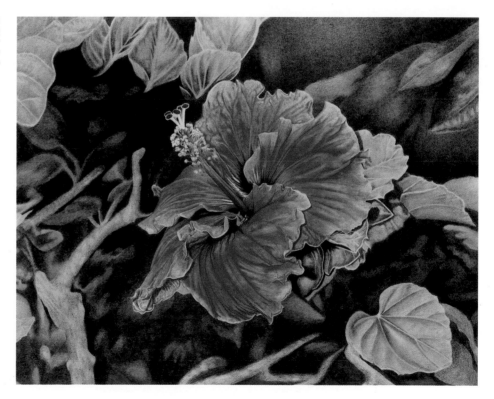

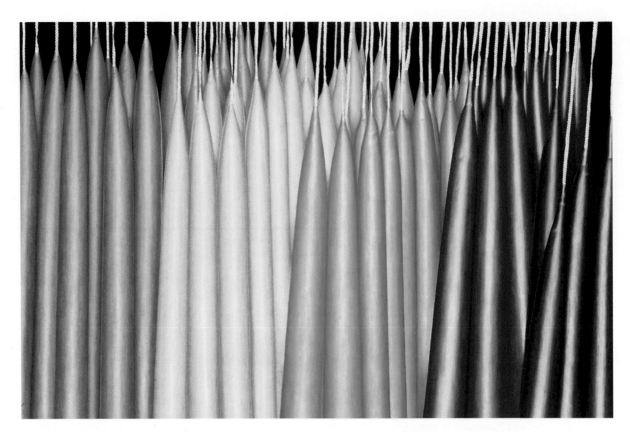

GARY GREENE
CANDLES 26" X 36"
EMPIRE BEROL USA AWA

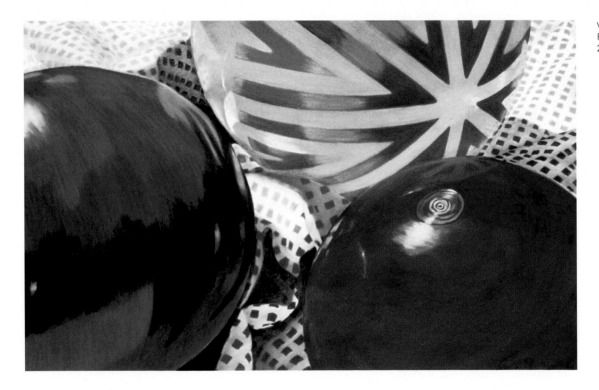

VALERIE RHATIGAN
REFLECTION IN COLOR I
24 ¹/₂" x 34"

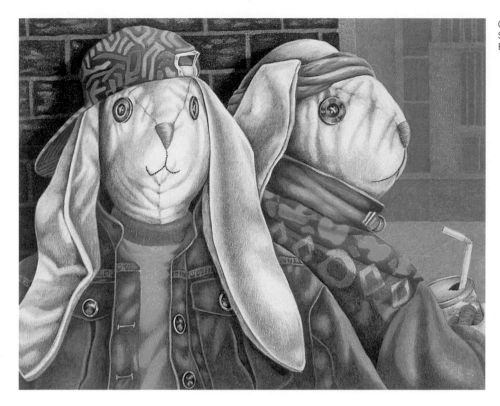

CINDY MIS SWIECH
SAM & CHARLY (*ABOVE*) 13 ½" x 17"
BEARS OF SUMMER (*BELOW*) 14" x 22"

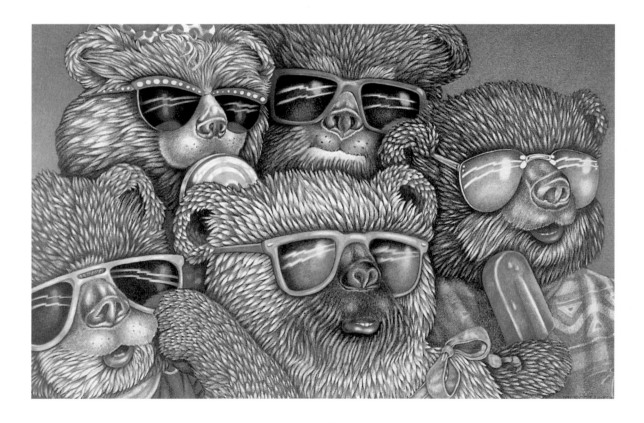

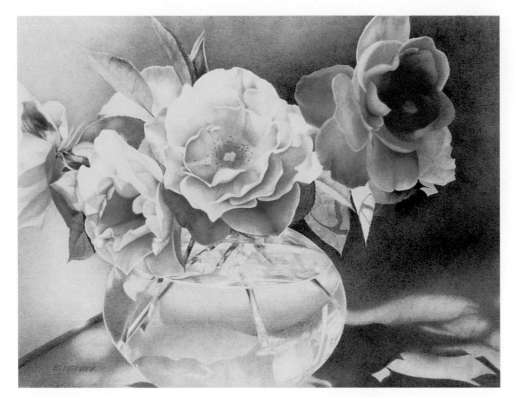

EDNA L. HENRY
ROSE BOWL
10 ½" x 14"

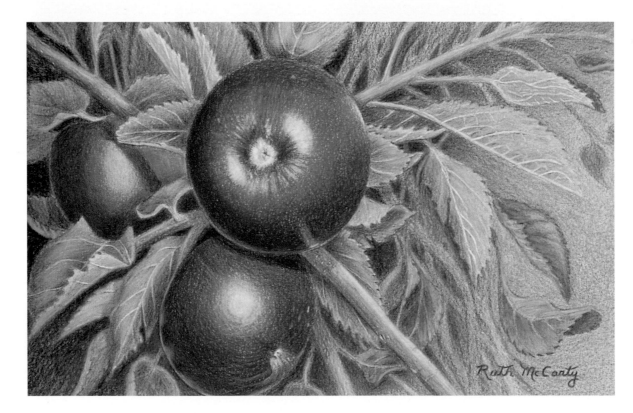

RUTH L. McCARTY
APPLES 14" x 16"

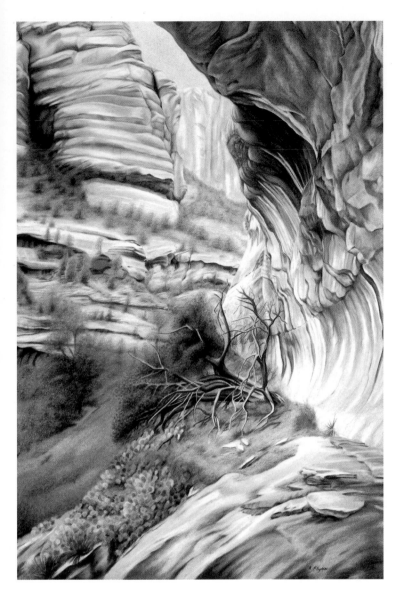

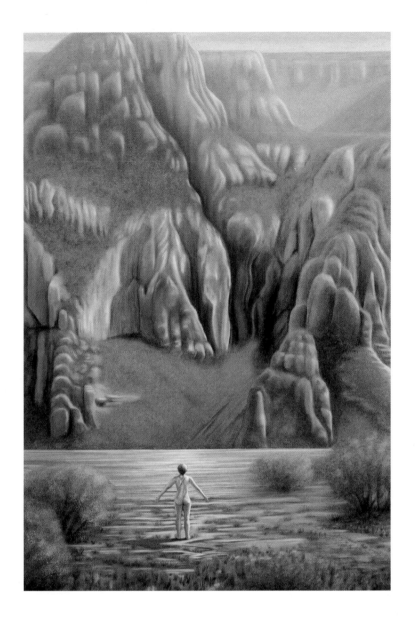

KATHARINE FLYNN
REFUGE (*LEFT*) 30" x 20"
INNER CHILD (*RIGHT*) 30" x 20"

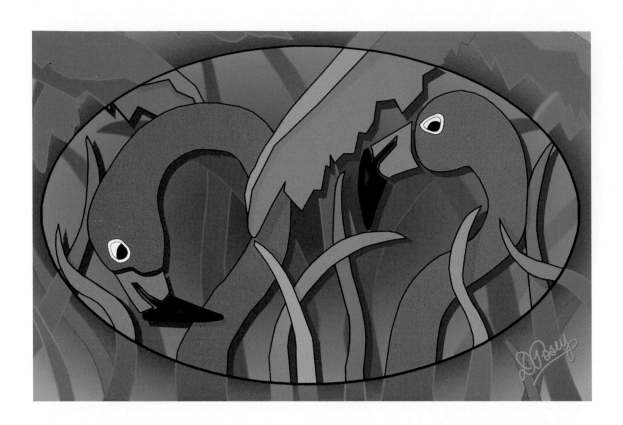

INTERLUDE

DESIGNER DAVID POSEY
SOFTWARE GENIGRAPHICS
HARDWARE GENIGRAPHICS 100D

AV VIDEO MAGAZINE COVER
INDEXING

DESIGNER STEVE HARLAN
SOFTWARE PAINT
HARDWARE MANAGEMENT GRAPHICS VISTAR

VIKING PENGUIN BOOK COVER

ILLUSTRATOR MARK YANKUS
SOFTWARE PHOTOSHOP
HARDWARE MAC IICX (32MB),
 SUPERMAC 19" MONITOR

DESIGNER DAVID CROSSLEY
DESIGN FIRM LIQUID PIXEL
SOFTWARE PHOTOSHOP, MONET, PAINTER,
COLOR STUDIO
HARDWARE MAC IICX, (8/330)

THE COMPLETE MIDI STUDIO

ILLUSTRATOR ADAM COHEN
DESIGNER MARC NEEDLEMAN
SOFTWARE PHOTOSHOP
HARDWARE MAC IIFX

THE COLORADO PROGRESSIVE AUTO INSURANCE CO.

ILLUSTRATOR ADAM COHEN
ART DIRECTOR SARA BURRIS
SOFTWARE PHOTOSHOP
HARDWARE MAC IIFX

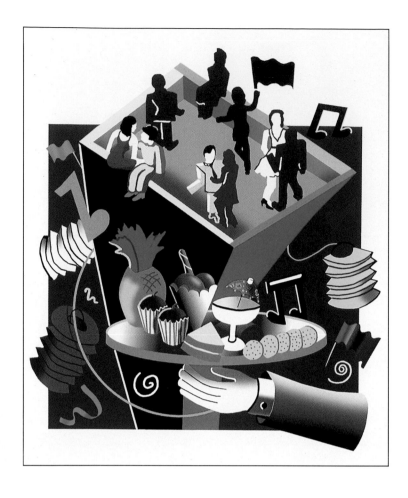

McGraw-Hill Party Invitation

ILLUSTRATOR Adam Cohen
DESIGNER Janet Millstein
SOFTWARE Photoshop
HARDWARE Mac IIfx

Blacklight Book Cover

ILLUSTRATOR Adam Cohen
DESIGNER Victor Weaver
SOFTWARE Photoshop
HARDWARE Mac IIfx

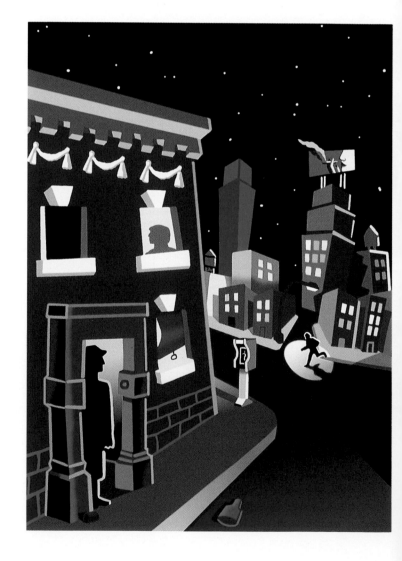

DESIGN FIRM	KAVISH & KAVISH
ART DIRECTOR	MICHAEL KAVISH
DESIGNER	DIANE FENSTER
CLIENT	ELECTRONIC ENTERTAINMENT magazine
SOFTWARE	ADOBE PHOTOSHOP, PAINT ALCHEMY
HARDWARE	MAC IIFX, NEXUS FX ACCELERATOR

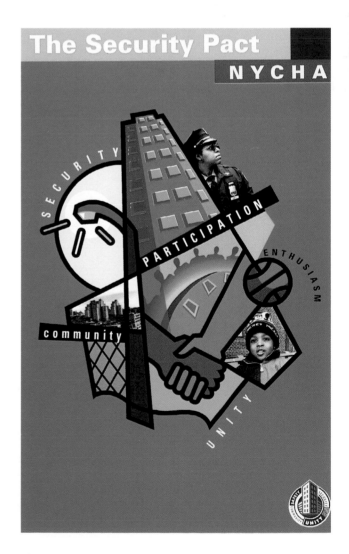

DESIGN FIRM	JAVIER ROMERO DESIGN GROUP
ART DIRECTOR	JAVIER ROMERO
DESIGNER	MARTIN FITZPATRICK
CLIENT	NEW YORK CITY HOUSING AUTHORITY
SOFTWARE	ADOBE ILLUSTRATOR
HARDWARE	MAC QUADRA

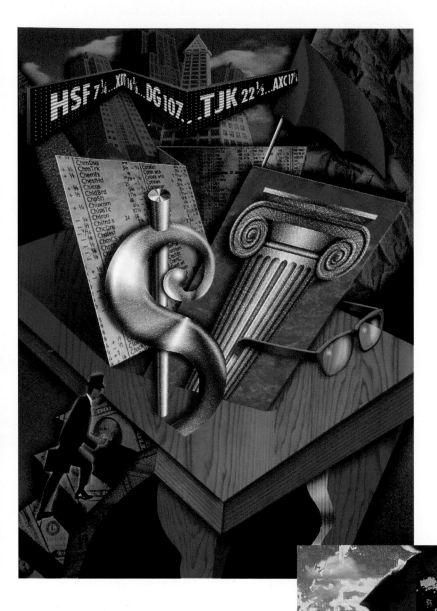

ILLUSTRATION FIRM STUDIO MD
ART DIRECTOR JAY PETROW, BUSINESS WEEK
ILLUSTRATOR GLENN MITSUI
CLIENT BUSINESS WEEK MAGAZINE
SOFTWARE ADOBE PHOTOSHOP, ALDUS FREEHAND, ADOBE ILLUSTRATOR
HARDWARE MAC IICX

ILLUSTRATION FIRM STUDIO MD
ART DIRECTOR KENT TAYANAKA, MACWORLD
ILLUSTRATOR GLENN MITSUI
CLIENT MACWORLD MAGAZINE
SOFTWARE FRACTAL DESIGN PAINTER
HARDWARE MAC IICX

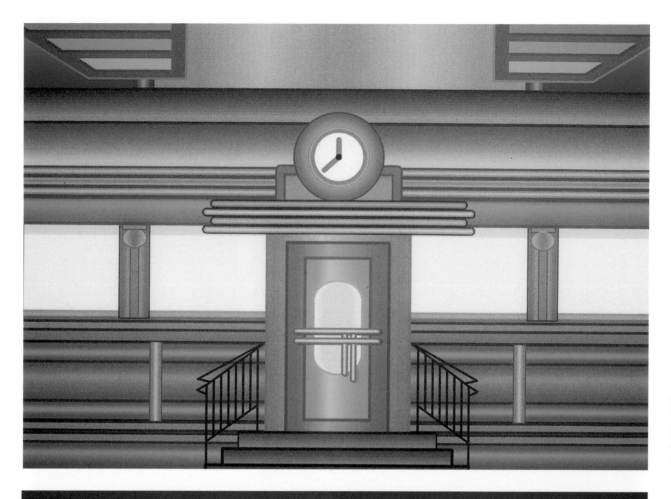

DESIGNER DAVID POSEY
CLIENT SELF-PROMOTION
SOFTWARE GENIGRAPHICS 100D+
HARDWARE GENIGRAPHICS

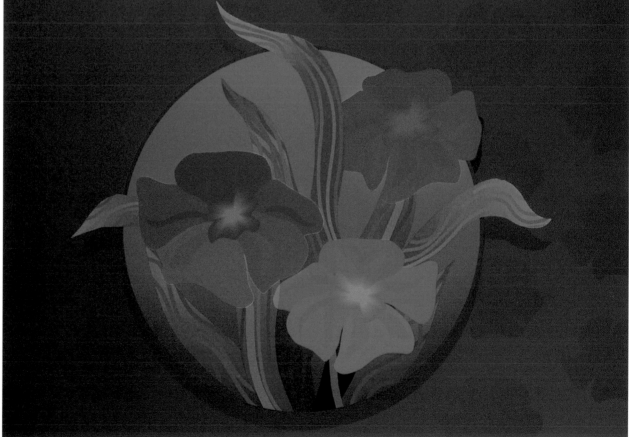

DESIGNER DAVID POSEY
CLIENT SELF-PROMOTION
SOFTWARE GENIGRAPHICS 100D+
HARDWARE GENIGRAPHICS

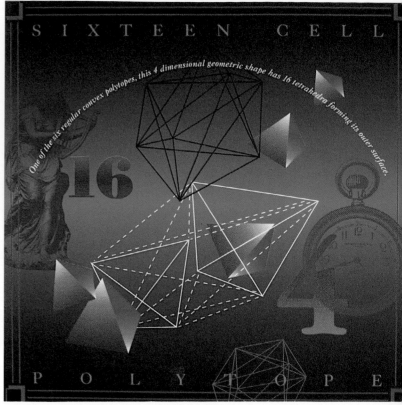

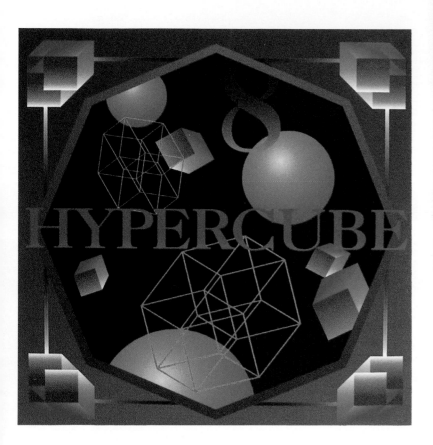

HYPERCUBE
DESIGN FIRM EDUINO J. PEREIRA, GRAPHIC DESIGN
DESIGNER EDUINO J. PEREIRA
CLIENT SELF-PROMOTION
SOFTWARE COREL DRAW

THIS IS A 4-DIMENSIONAL REPRESENTATION OF A CUBE

16 CELL
DESIGN FIRM EDUINO J. PEREIRA, GRAPHIC DESIGN
DESIGNER EDUINO J. PEREIRA
CLIENT SELF-PROMOTION
SOFTWARE COREL DRAW
HARDWARE IBM PC 386

*ONE OF THE SIX REGULAR CONVEX POLYTOPES; IT HAS
16 TETRAHEDRA ON ITS SURFACE.*

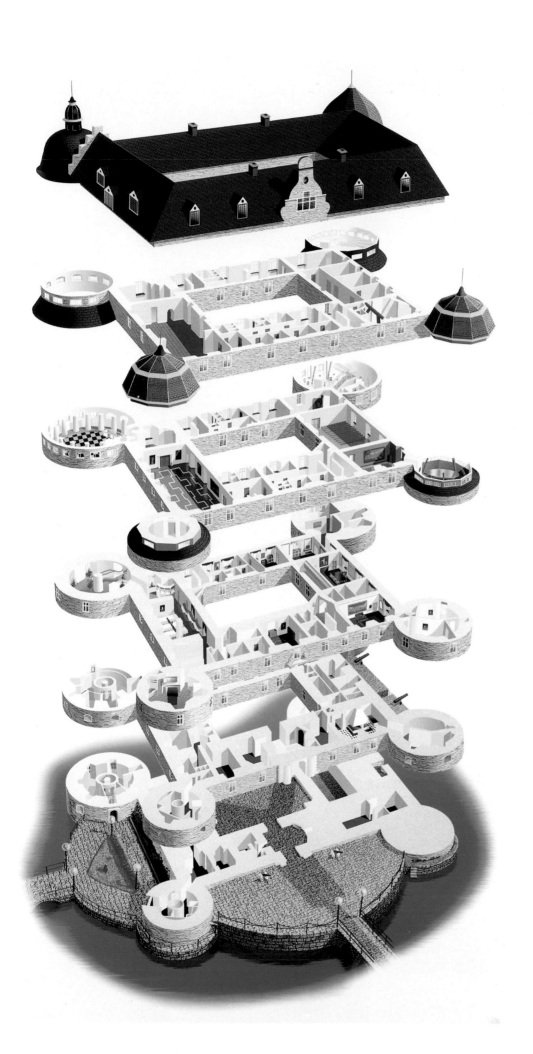

DESIGN FIRM BO LILJEDAL REKLAMBYRA
ART DIRECTOR PER-IVAR FROJO
DESIGNER PHILIP NICHOLSON
CLIENT OREBRO SLOTT
SOFTWARE ADOBE ILLUSTRATOR,
 ADOBE DIMENSIONS,
 FRACTAL DESIGN PAINTER
HARDWARE MAC QUADRA 950

THE PAINT FACTORY

DESIGNER CHRISTOPHER PALLOTTA
SOFTWARE ALDUS FREEHAND, FRACTAL DESIGN
PAINTER, ADOBE PHOTOSHOP
HARDWARE MAC

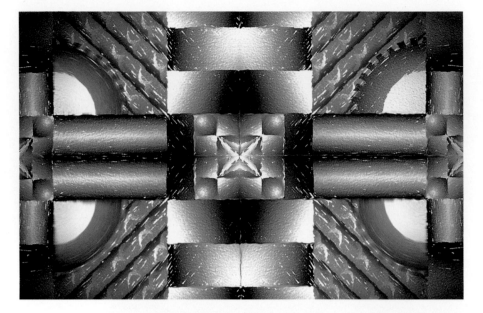

LANDSCAPE

DESIGNER CHRISTOPHER PALLOTTA
SOFTWARE ADOBE PHOTOSHOP
HARDWARE MAC

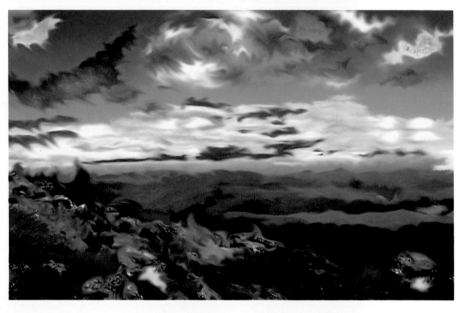

INDUSTRIAL VORTEX

DESIGNER CHRISTOPHER PALLOTTA
SOFTWARE ADOBE PHOTOSHOP, FRACTAL
DESIGN PAINTER
HARDWARE MAC

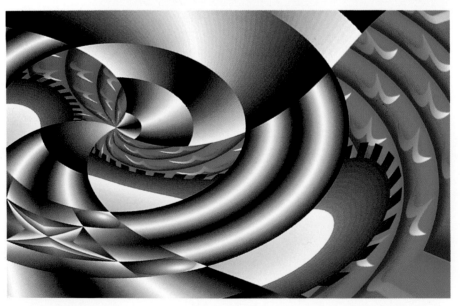

34

STRAWBERRY BLONDE

DESIGN FIRM	RHODA GROSSMAN GRAPHICS
ART DIRECTOR	RHODA GROSSMAN
DESIGNER	RHODA GROSSMAN
CLIENT	THE DIGITAL POND
SOFTWARE	FRACTAL DESIGN PAINTER
HARDWARE	MAC II, KURTA XGT TABLET,
	MIRROR 600 COLOR SCANNER

THE DESIGNER USED AUDREY HEPBURN'S MOUTH AND INGRID BERGMAN'S EYES IN THIS IMAGE.

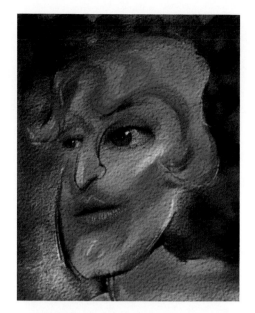

KEITH/SEYBOLD

DESIGN FIRM	RHODA GROSSMAN GRAPHICS
ART DIRECTOR	RHODA GROSSMAN
DESIGNER	RHODA GROSSMAN
CLIENT	KURTA CORPORATION
SOFTWARE	FRACTAL DESIGN PAINTER
HARDWARE	QUADRA, KURTA XGT TABLET

THIS IS AN ON-THE-SPOT DEMO DONE AT A SEYBOLD TRADE SHOW: THE VOLUNTEER POSES WHILE THE ARTIST PAINTS HIM OR HER IN A MIXED MEDIA STYLE, WHICH INCLUDES SCANNED ITEMS FROM AN ELECTRONIC "PORTFOLIO" OF FACIAL FEATURES.

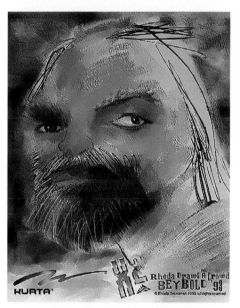

EVELYN/SEYBOLD

DESIGN FIRM	RHODA GROSSMAN GRAPHICS
ART DIRECTOR	RHODA GROSSMAN
DESIGNER	RHODA GROSSMAN
CLIENT	KURTA CORPORATION
SOFTWARE	FRACTAL DESIGN PAINTER
HARDWARE	QUADRA, KURTA XGT TABLET

THIS IMAGE WAS CREATED IN ABOUT FIFTEEN MINUTES AS A DEMO AT A SEYBOLD TRADE SHOW. SOME ELEMENTS, SUCH AS FACIAL FEATURES AND BORDERS, WERE SCANNED IN ADVANCE AND THEN COMBINED WITH PAINTING TECHNIQUE.

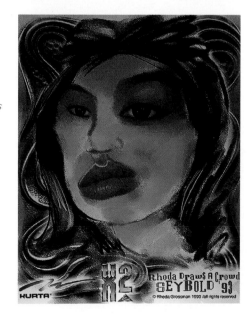

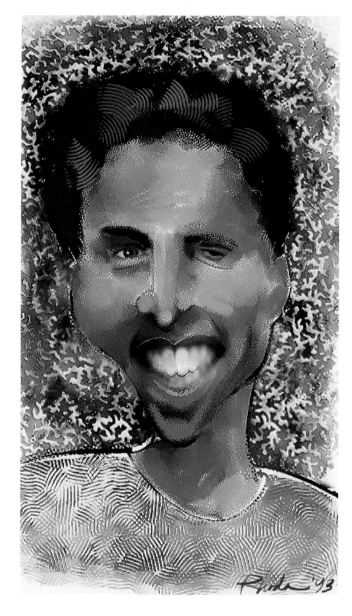

MHJ JOE

DESIGN FIRM	RHODA GROSSMAN GRAPHICS
ART DIRECTOR	RHODA GROSSMAN
DESIGNER	RHODA GROSSMAN
CLIENT	MAC HOME JOURNAL
SOFTWARE	FRACTAL DESIGN PAINTER
HARDWARE	QUADRA, KURTA XGT TABLET,
	MIRROR 600 COLOR SCANNER

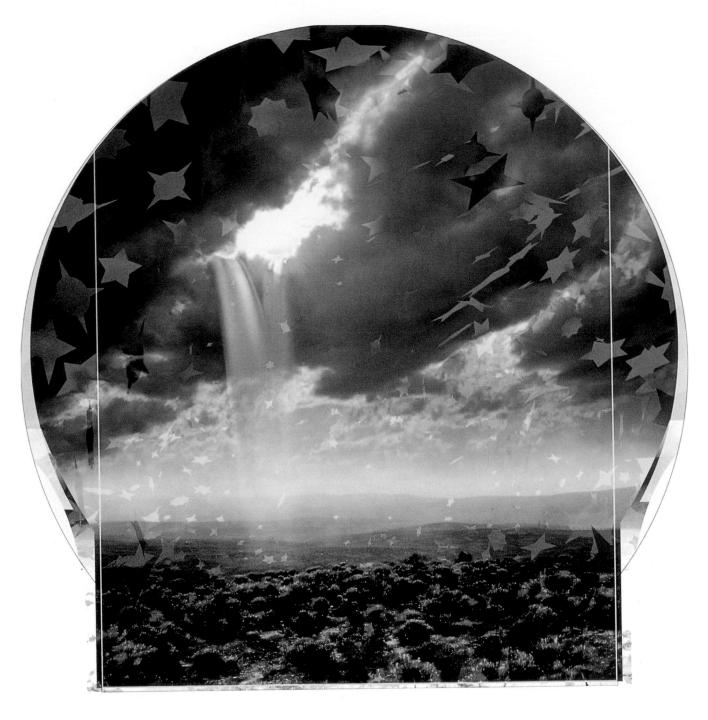

CLOUD BURST

DESIGN FIRM	INTERACT
ART DIRECTOR	GREG VANDER HOUWEN
DESIGNER	GREG VANDER HOUWEN
SOFTWARE	ADOBE PHOTOSHOP, FRACTAL DESIGN PAINTER, ADOBE ILLUSTRATOR
HARDWARE	MAC, WACOM TABLET

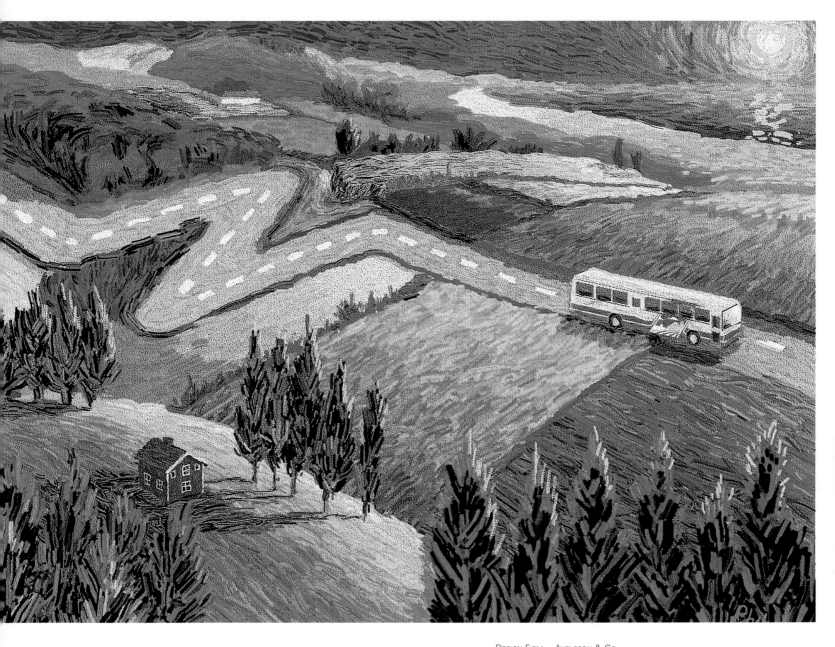

DESIGN FIRM AXELSSON & CO.
ART DIRECTOR MATS NILSSON
DESIGNER PHILIP NICHOLSON
CLIENT HALLANDSTRAFIKEN
SOFTWARE FRACTAL DESIGN PAINTER
HARDWARE MAC QUADRA 950

DESIGN FIRM ADAM COHEN/ILLUSTRATOR
ART DIRECTOR CHRISTINA WALKER
CLIENT SPEC'S MUSIC/CN WALKER GROUP
SOFTWARE ADOBE PHOTOSHOP
HARDWARE MAC IIFX

THESE ARE THREE OUT OF NINE MURALS CREATED FOR SPEC'S.

ILLUSTRATOR ADAM COHEN
ART DIRECTOR LESLIE SINGER
CLIENT MIS PRESS/HENRY HOLT & CO.
SOFTWARE ADOBE PHOTOSHOP
HARDWARE MAC IIFX

HAPPY DAFFS

ART DIRECTOR DONALD GAMBINO
DESIGNER DONALD GAMBINO
CLIENT SELF-PROMOTION
SOFTWARE ADOBE PHOTOSHOP
HARDWARE MAC QUADRA 800

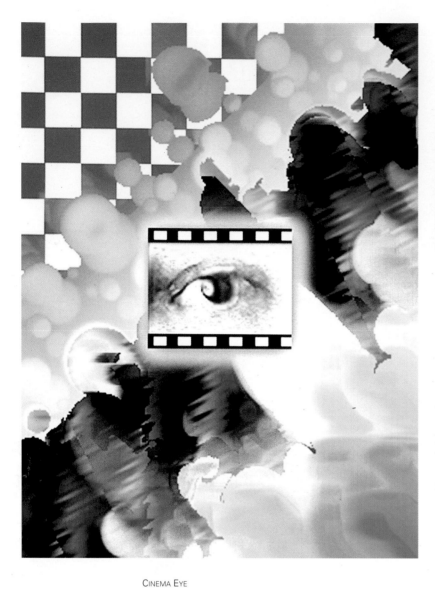

CINEMA EYE

ILLUSTRATOR DONALD GAMBINO
CLIENT SELF-PROMOTION
SOFTWARE ADOBE PHOTOSHOP
HARDWARE MAC QUADRA 800

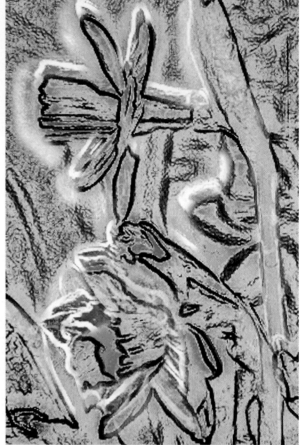

TOKEN WREATH

ILLUSTRATOR DONALD GAMBINO
CLIENT SELF-PROMOTION
SOFTWARE ADOBE PHOTOSHOP
HARDWARE MAC QUADRA 800

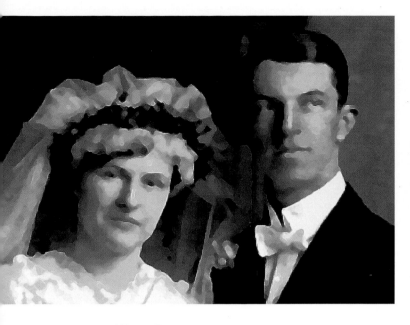

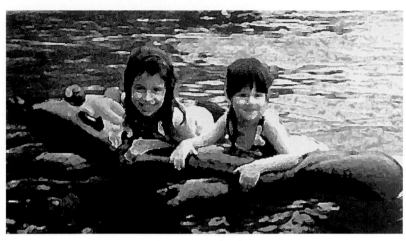

WEDDING DAY

DESIGN FIRM	HATFIELD DESIGN
ART DIRECTOR	LEE HATFIELD
DESIGNER	LEE HATFIELD
CLIENT	SELF-PROMOTION
SOFTWARE	COREL DRAW, FRACTAL DESIGN PAINTER
HARDWARE	IBM PC 486

2 COUSINS

DESIGN FIRM	HATFIELD DESIGN
ART DIRECTOR	LEE HATFIELD
DESIGNER	LEE HATFIELD
CLIENT	SELF-PROMOTION
SOFTWARE	COREL DRAW, FRACTAL DESIGN PAINTER
HARDWARE	IBM PC

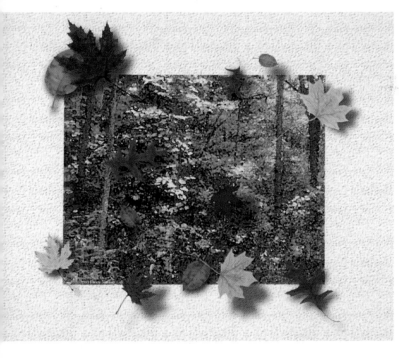

AUTUMN WOODS

ART DIRECTOR	RANDY SOWASH
DESIGNER	RANDY SOWASH
SOFTWARE	ADOBE PHOTOSHOP
HARDWARE	MAC IISI

SUNDAY IN THE PARK

ART DIRECTOR	RANDY SOWASH
SOFTWARE	ADOBE PHOTOSHOP, FRACTAL DESIGN PAINTER
HARDWARE	MAC IISI

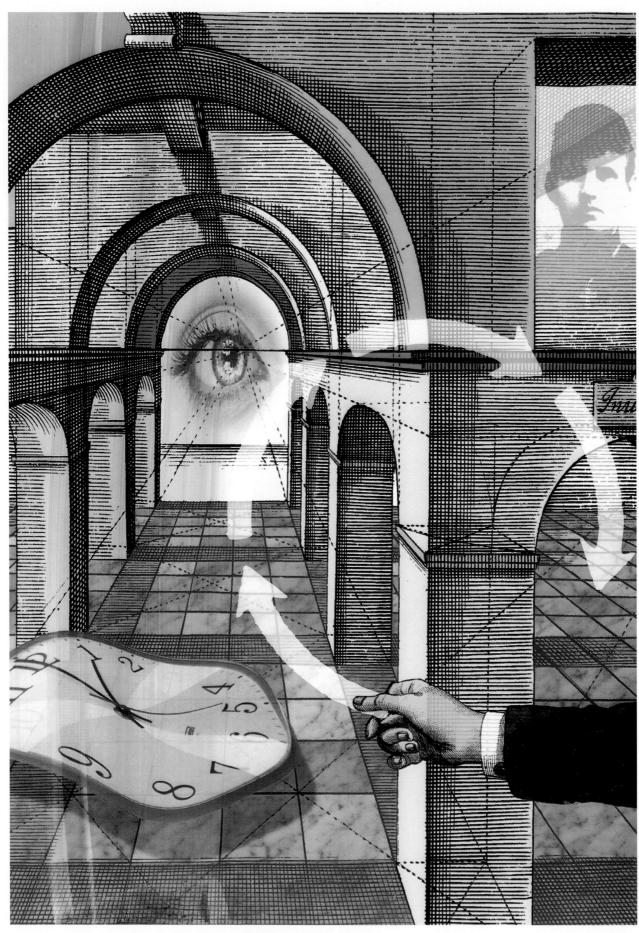

DESIGN FIRM PENWELL GRAPHICS
ART DIRECTOR BRUCE SANDERS
ILLUSTRATOR MARC YANKUS
CLIENT COMPUTER ARTIST MAGAZINE
SOFTWARE ADOBE PHOTOSHOP
HARDWARE MAC QUADRA 950

THIS DESIGN WAS FOR THE COVER OF COMPUTER ARTIST MAGAZINE

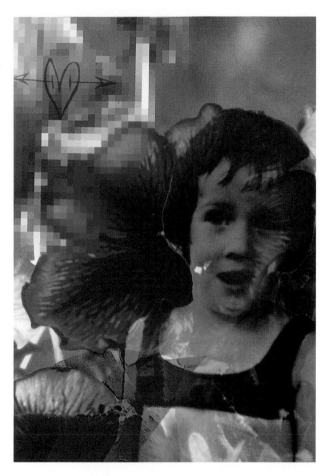

DESIGN FIRM HA! HAYDEN & ASSOCIATES
ILLUSTRATOR KATIE HAYDEN
CLIENT SELF-PROMOTION
SOFTWARE ADOBE PHOTOSHOP
HARDWARE MAC IICI

DESIGN FIRM HA! HAYDEN & ASSOCIATES
ILLUSTRATOR KATIE HAYDEN
CLIENT SELF-PROMOTION
SOFTWARE ADOBE PHOTOSHOP
HARDWARE MAC IICI

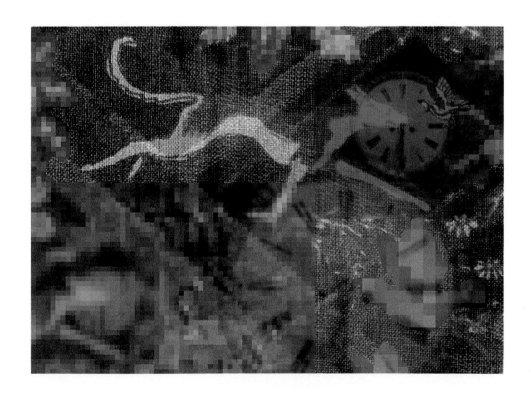

DESIGN FIRM BETH SANTOS DESIGN
ART DIRECTOR BETH SANTOS
DESIGNER BETH SANTOS
CLIENT SELF-PROMOTION
SOFTWARE ADOBE PHOTOSHOP
HARDWARE MAC II

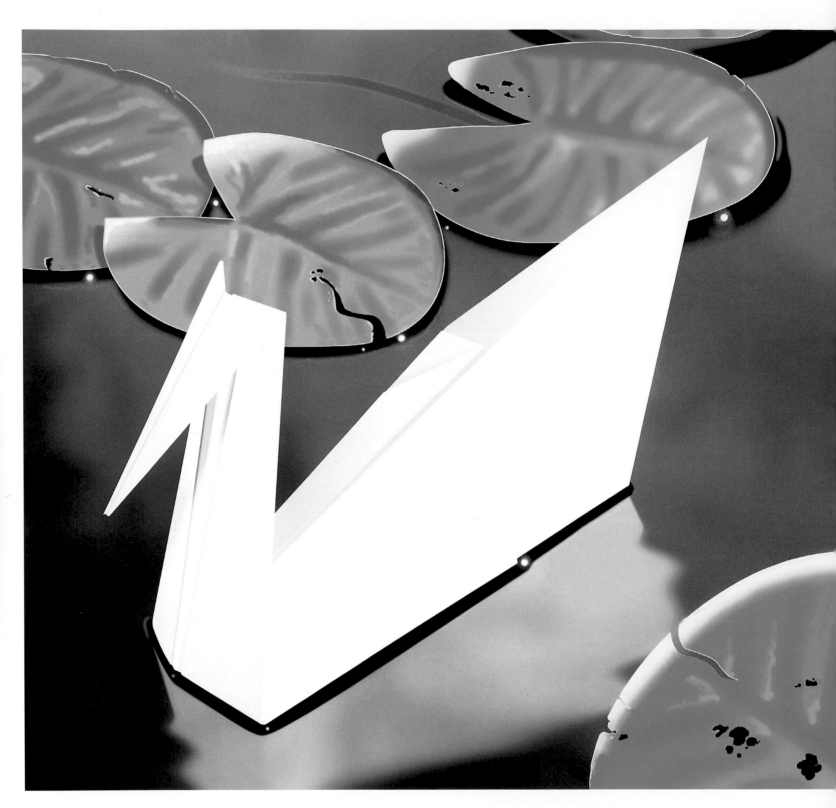

DESIGN FIRM AXELSSON & CO.
ART DIRECTOR ROBERT KIRTLEY
DESIGNER PHILIP NICHOLSON
CLIENT TRYCMEDIA
SOFTWARE ADOBE ILLUSTRATOR,
 ADOBE PHOTOSHOP
HARDWARE MAC QUADRA 950

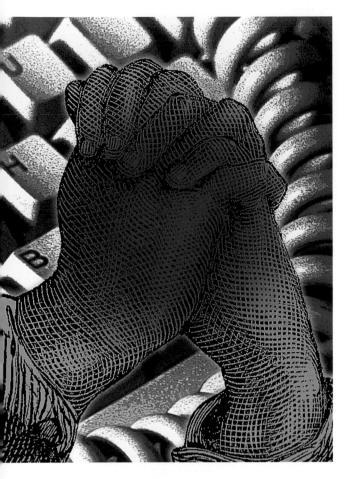

DESIGNER JACQUELINE COMSTOCK
SOFTWARE ADOBE PHOTOSHOP
HARDWARE MAC IIFX

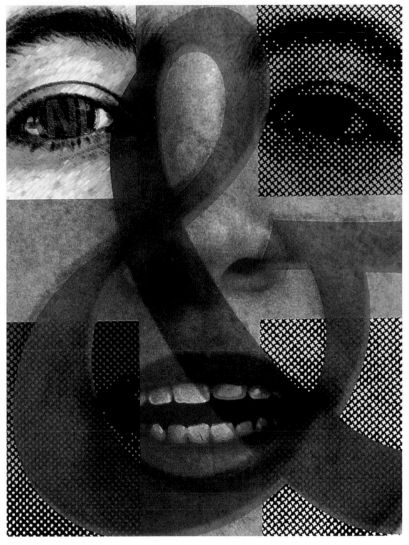

DESIGNER JACQUELINE COMSTOCK
SOFTWARE ADOBE PHOTOSHOP
HARDWARE MAC IICX

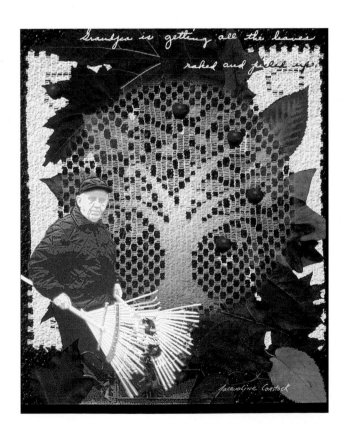

DESIGNER JACQUELINE COMSTOCK
SOFTWARE FRACTAL DESIGN PAINTER, ALDUS GALLERY EFFECTS, ADOBE PHOTOSHOP
HARDWARE MAC IICX

45

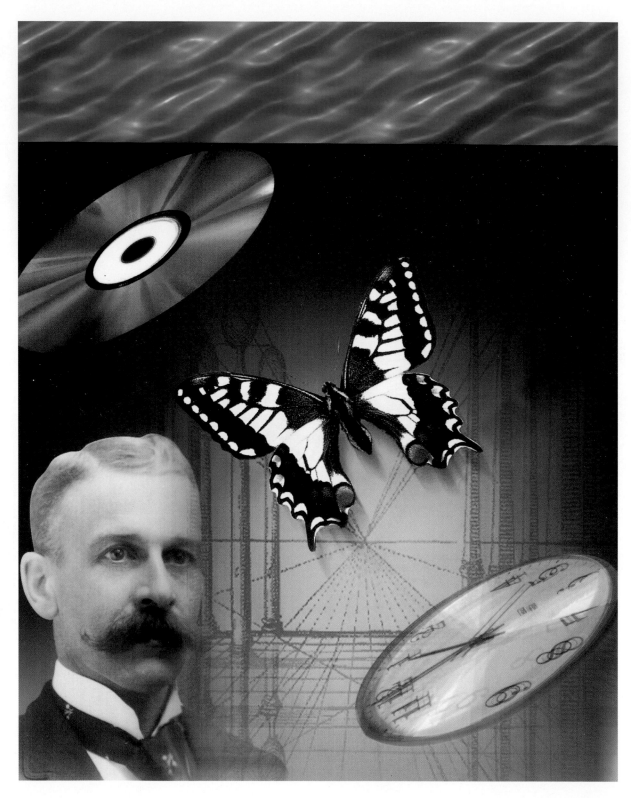

DESIGN FIRM ANDROMEDA SOFTWARE
ART DIRECTOR MARC YANKUS
DESIGNER MARC YANKUS
CLIENT SELF-PROMOTION
SOFTWARE ADOBE PHOTOSHOP
HARDWARE MAC QUADRA 950

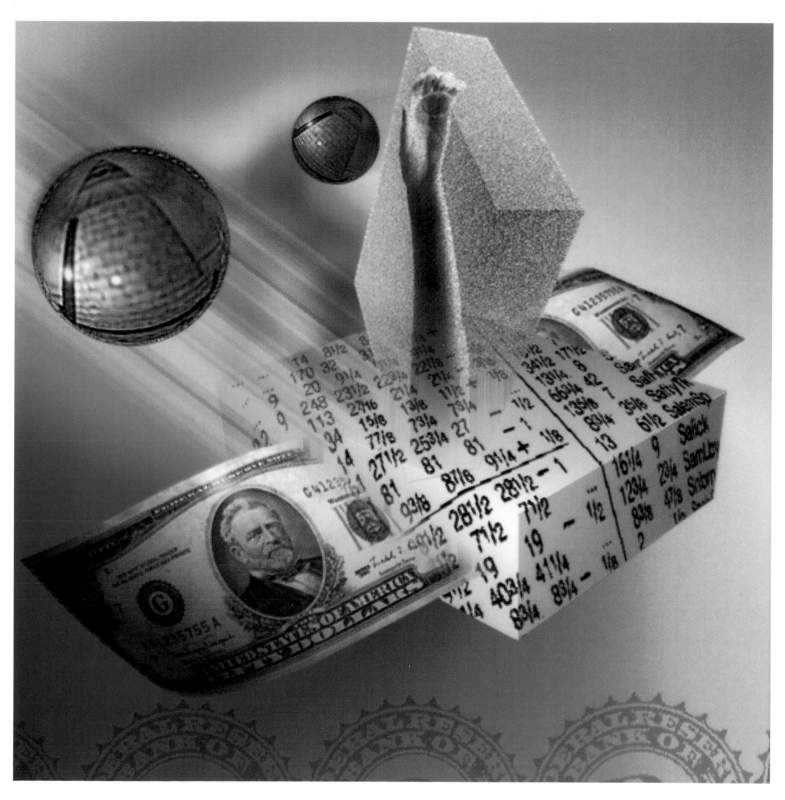

ILLUSTRATOR MARC YANKUS
SOFTWARE ADOBE PHOTOSHOP
HARDWARE MAC QUADRA 950

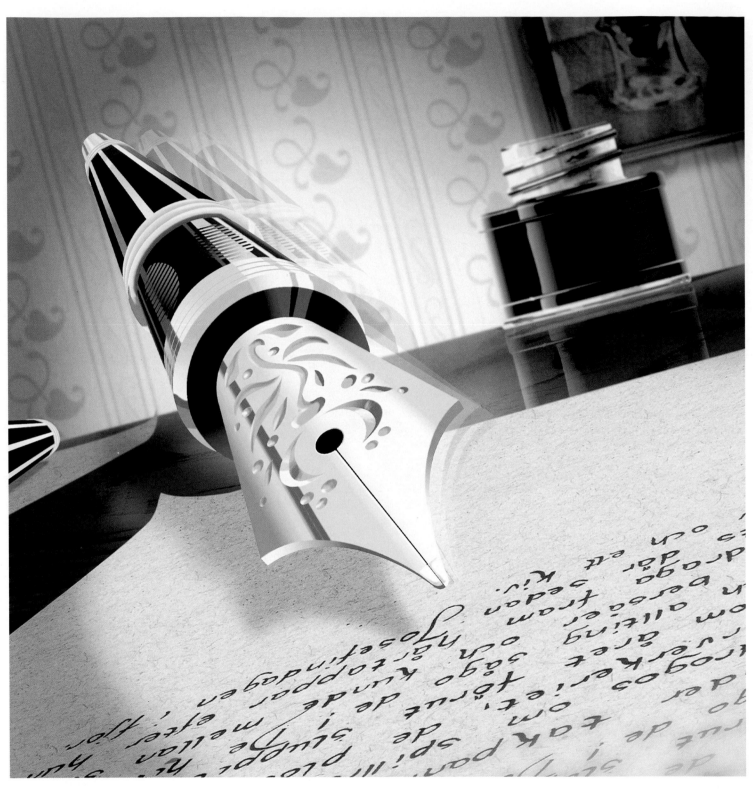

DESIGN FIRM	AXELSSON & CO.
ART DIRECTOR	ROBERT KIRTLEY
DESIGNER	PHILIP NICHOLSON
CLIENT	TRYCKMEDIA
SOFTWARE	ADOBE ILLUSTRATOR,
	ADOBE PHOTOSHOP
HARDWARE	MAC QUADRA 950

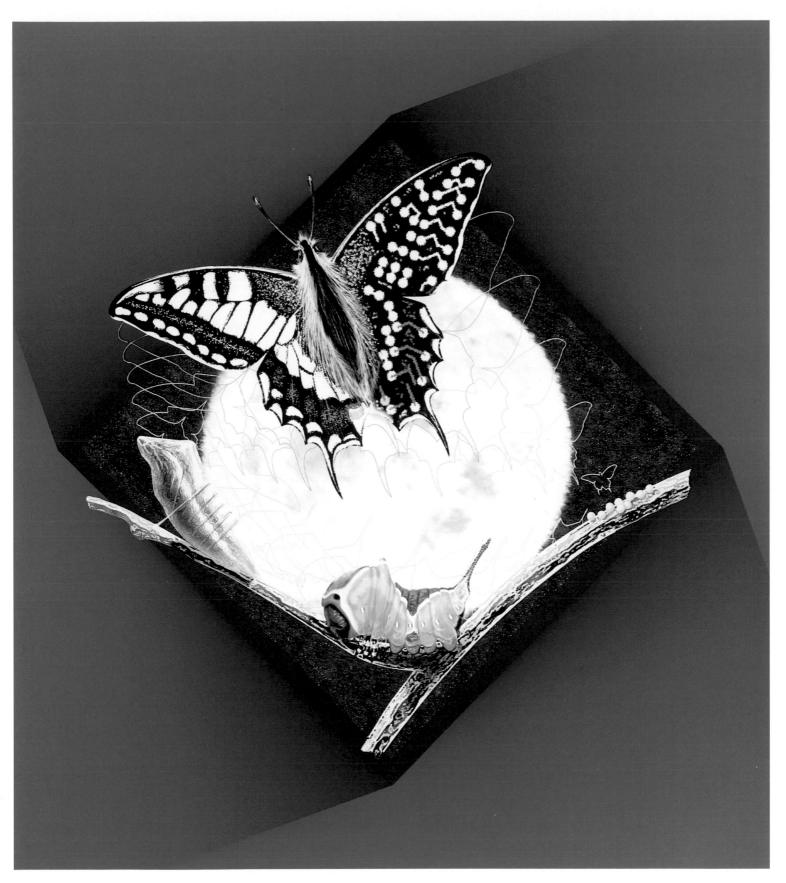

DESIGNER PHILIP NICHOLSON
CLIENT HOGIA DATA
SOFTWARE ADOBE ILLUSTRATOR,
 ADOBE PHOTOSHOP,
 FRACTAL DESIGN PAINTER
HARDWARE MAC QUADRA 950

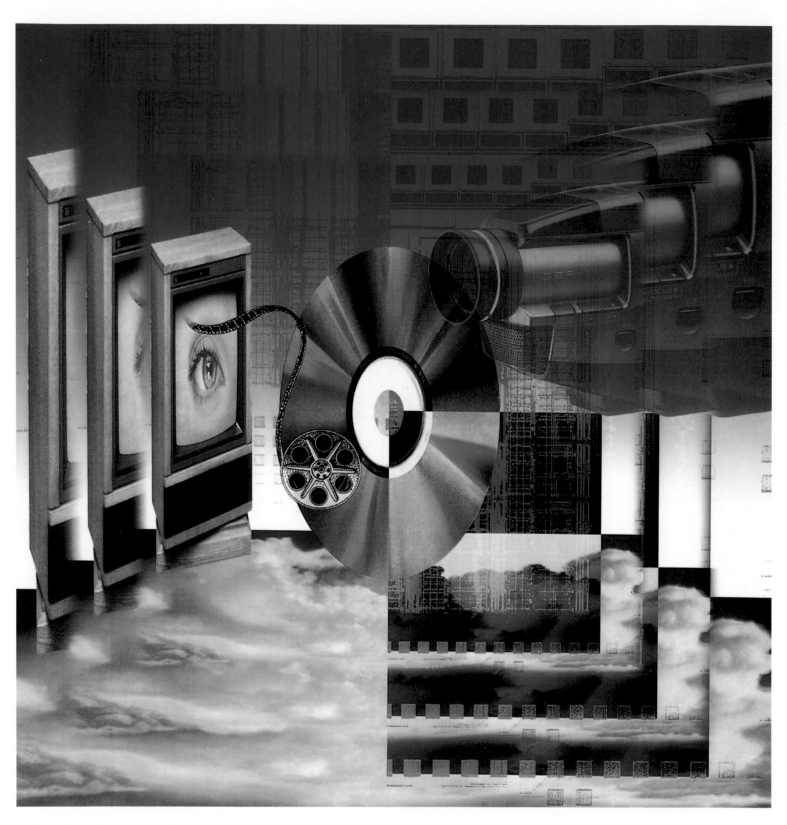

DESIGN FIRM POPULAR SCIENCE MAGAZINE
ART DIRECTOR TOM WHITE
ILLUSTRATOR MARC YANKUS
SOFTWARE ADOBE PHOTOSHOP
HARDWARE MAC QUADRA 950

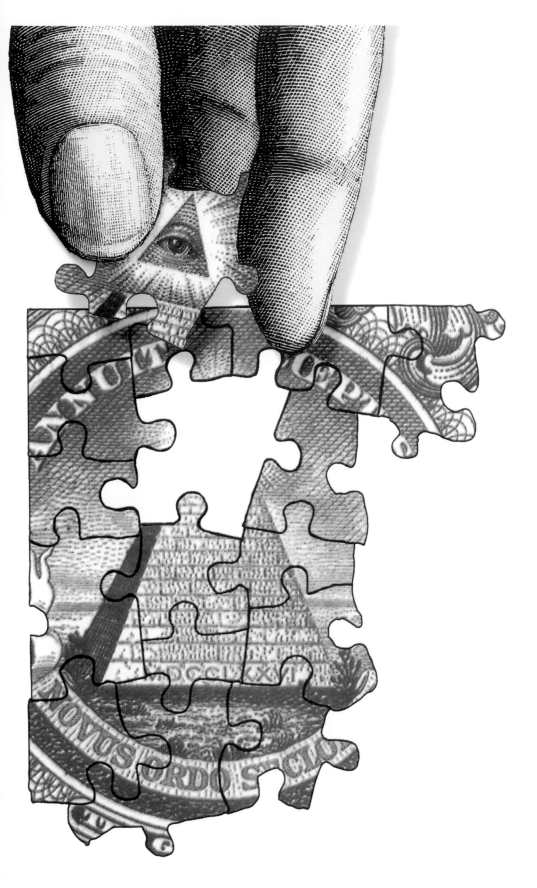

DESIGN FIRM CLARK KELLOGG DESIGN
ART DIRECTOR CLARK KELLOGG
DESIGNER MARC YANKUS
CLIENT BANKERS TRUST
SOFTWARE ADOBE PHOTOSHOP
HARDWARE MAC QUADRA 950

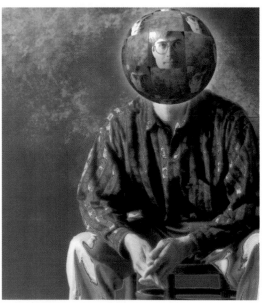

DESIGN FIRM TIME MAGAZINE
ART DIRECTOR BILL POWERS
ILLUSTRATOR MARC YANKUS
SOFTWARE ADOBE PHOTOSHOP
HARDWARE MAC QUADRA 950

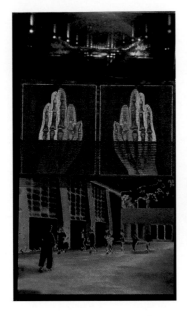
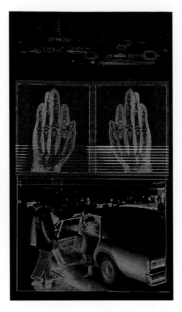
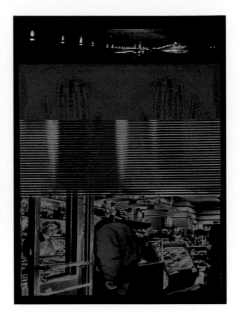

DESIGNER DIANE FENSTER, COMPUTER ART & DESIGN
SOFTWARE ADOBE PHOTOSHOP
HARDWARE MACFX, NEXUS FX ACCELERATOR

THESE ARE SELECTIONS FROM "THE POINT OF EMERGENCE" SERIES.

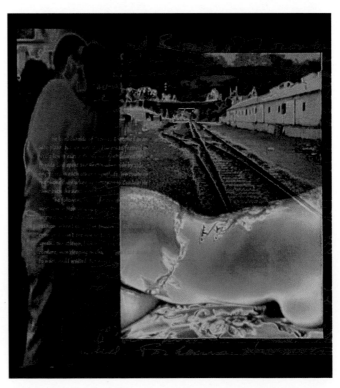

DESIGNER DIANE FENSTER
SOFTWARE ADOBE PHOTOSHOP
HARDWARE MACFX, NEXUS FX ACCELERATOR

THESE ARE SIX IMAGES FROM THE "RITUAL OF ABANDONMENT" SERIES.

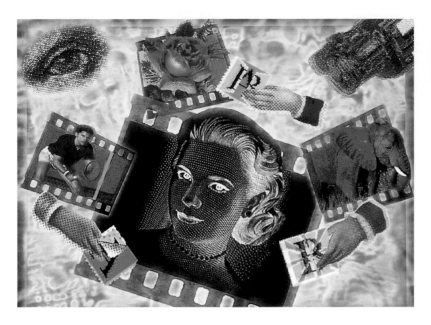

ART DIRECTOR SYLVIA BENVENUTTI
DESIGNER DIANE FENSTER
CLIENT MACWORLD MAGAZINE
SOFTWARE ADOBE PHOTOSHOP
HARDWARE MACFX, NEXUS FX ACCELERATOR

THIS IS A PREMIERE 3.0 EDITORIAL ILLUSTRATION.

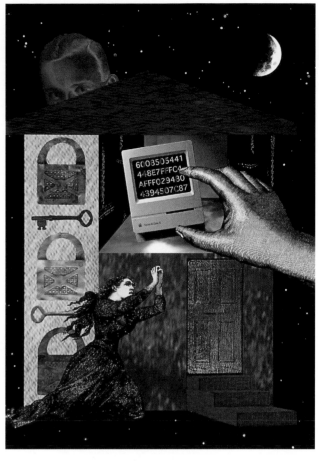

DATA GUARDIANS

ART DIRECTOR SYLVIA BENVENUTTI
DESIGNER DIANE FENSTER
CLIENT MACWORLD MAGAZINE
SOFTWARE ADOBE PHOTOSHOP
HARDWARE MACFX, NEXUS FX ACCELERATOR

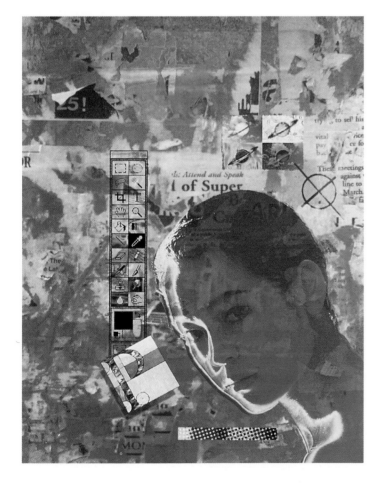

DESIGN FIRM KAVISH & KAVISH
ART DIRECTOR MICHAEL KAVISH
DESIGNER DIANE FENSTER
CLIENT IDG BOOKS
SOFTWARE ADOBE PHOTOSHOP
HARDWARE MACFX, NEXUS FX ACCELERATOR

THIS IS A BIBLE COVER ILLUSTRATION.

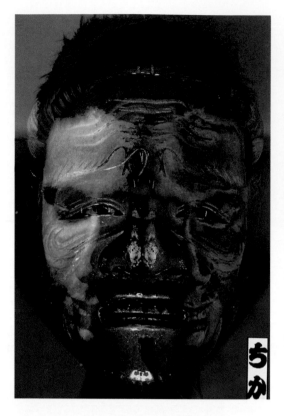

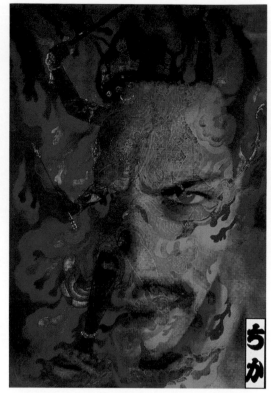

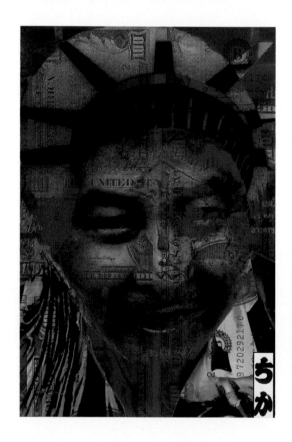

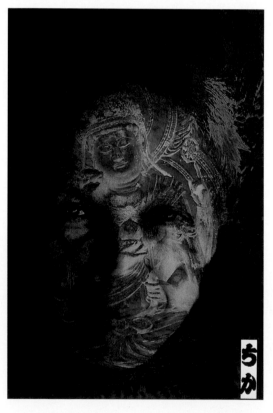

DESIGNER CHIKA IIJIMA
SOFTWARE ADOBE PHOTOS
HARDWARE MAC

THE GOLF CLUB OF OREGON

WILLIAM ZMISTOWSKI ASSOCIATES ARCHITECTS

GOLF COURSE DEVELOPMENT IS A SPECIALTY THAT DEMANDS THAT THE ILLUSTRATOR KNOW AS MUCH ABOUT THE GAME OF GOLF AS HE DOES ABOUT ARCHITECTURE. A HIGHLY DEVELOPED SENSE OF REALISM IS CALLED FOR IN BOTH AREAS.

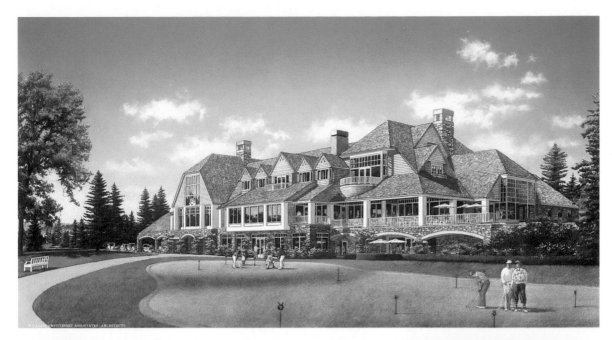

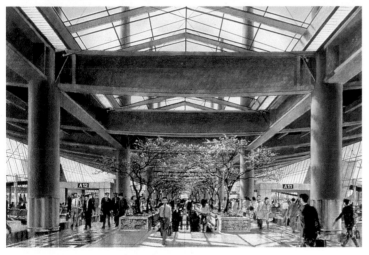

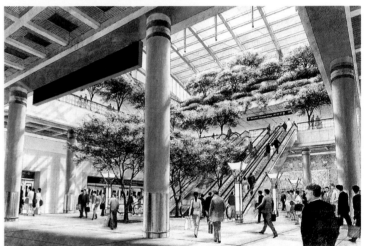

NEW SEOUL
METROPOLITAN AIRPORT
SEOUL, KOREA

C.W. FENTRESS, J.H. BRADBURN & ASSOCIATES P.C. ARCHITECTS

THESE DRAWINGS ARE THREE OF A SERIES OF VIEWS CREATED FOR AN INTERNATIONAL COMPETITION. THEY EMPHASIZE THE STRONG USE OF NATURAL LIGHT, THE DRAMATIC STRUCTURE, THE EXPANSIVE SPACES, AND THE BOLD USE OF COLOR INHERENT IN THIS WINNING DESIGN.

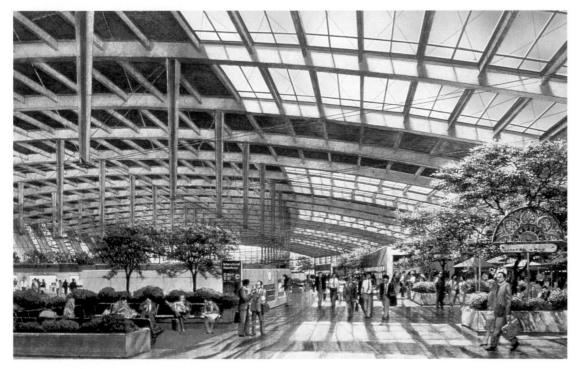

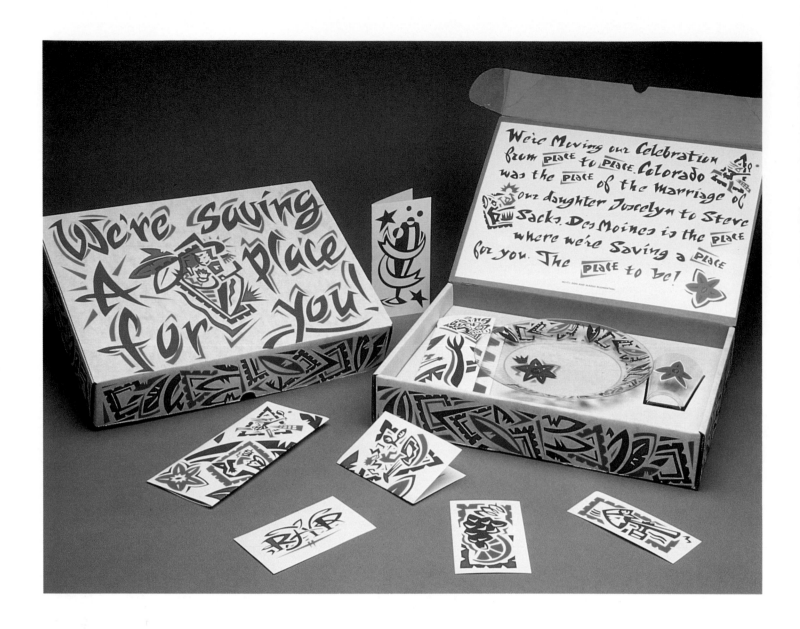

We're Moving our Celebration from place to place. Colorado was the place of the marriage of our daughter Jocelyn to Steve Sacks. Des Moines is the place where we're saving a place for you. The place to be!

DESIGN FIRM SAYLES GRAPHIC DESIGN
ART DIRECTOR JOHN SAYLES
DESIGNER JOHN SAYLES
OCCASION WEDDING
ILLUSTRATOR JOHN SAYLES
CLIENT THE BLUMENTHAL FAMILY

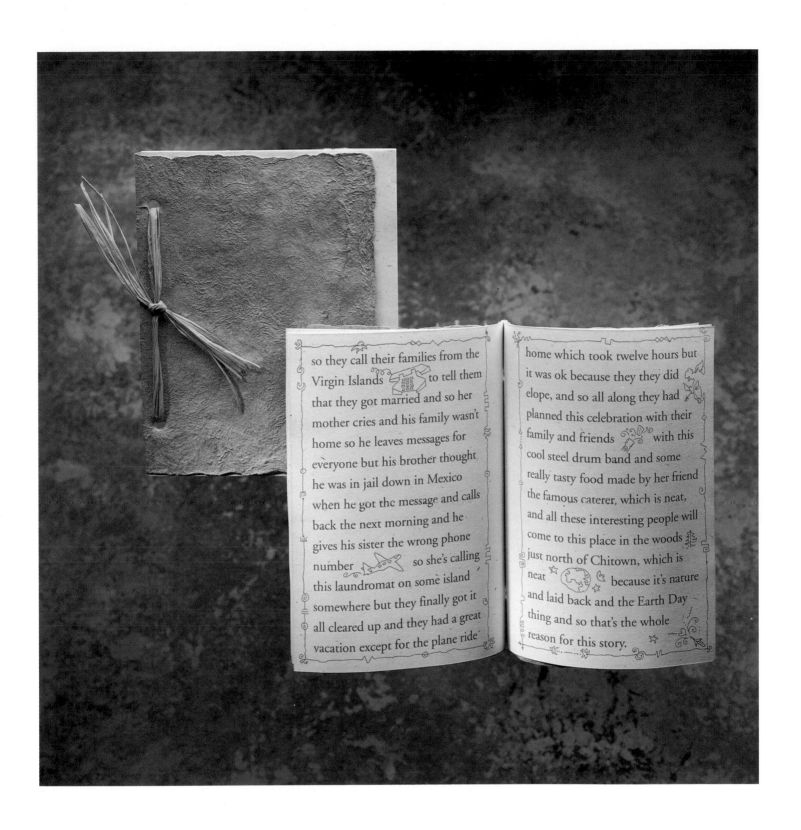

so they call their families from the Virgin Islands to tell them that they got married and so her mother cries and his family wasn't home so he leaves messages for everyone but his brother thought he was in jail down in Mexico when he got the message and calls back the next morning and he gives his sister the wrong phone number so she's calling this laundromat on some island somewhere but they finally got it all cleared up and they had a great vacation except for the plane ride home which took twelve hours but it was ok because they they did elope, and so all along they had planned this celebration with their family and friends with this cool steel drum band and some really tasty food made by her friend the famous caterer, which is neat, and all these interesting people will come to this place in the woods just north of Chitown, which is neat because it's nature and laid back and the Earth Day thing and so that's the whole reason for this story.

DESIGN FIRM MARK OLDACH DESIGN
ART DIRECTOR MARK OLDACH
DESIGNER MARK OLDACH
OCCASION WEDDING INVITATION
ILLUSTRATOR MARK OLDACH
CLIENT MARK OLDACH, JANET LORAT

DESIGN FIRM SULLIVANPERKINS
ART DIRECTOR RON SULLIVAN
DESIGNER LINDA KELTON
OCCASION BIRTH ANNOUNCEMENT
ILLUSTRATOR LINDA KELTON
CLIENT DUFFY WEIR

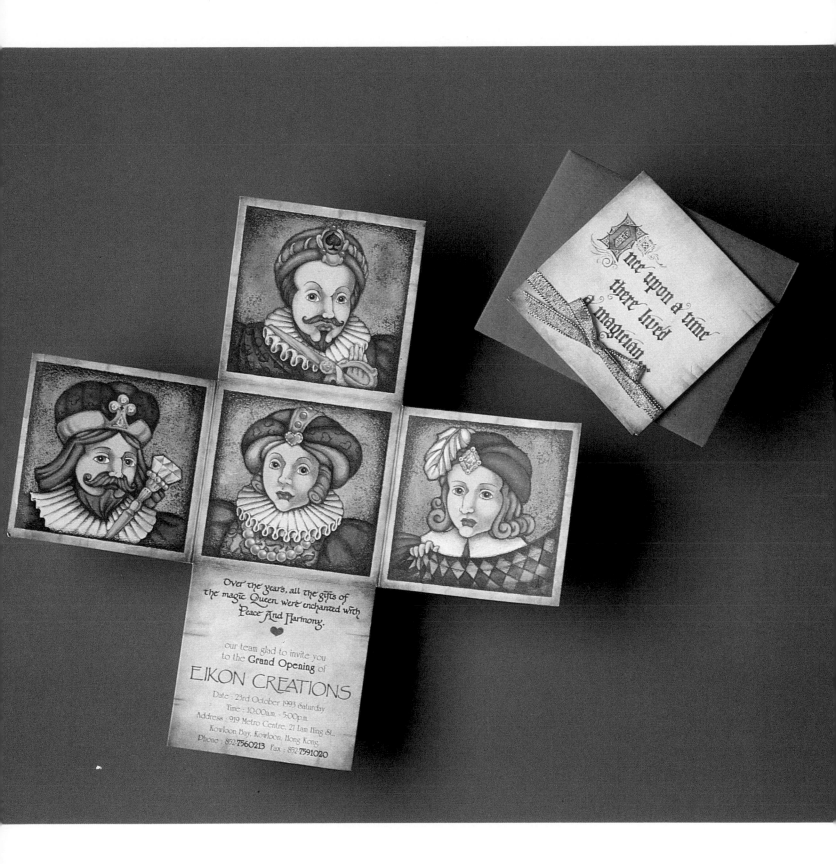

DESIGN FIRM EIKON CREATIONS
ART DIRECTOR HEIDE KWOK
DESIGNER TOMMY WONG, KENNETH CHOI
OCCASION GRAND OPENING
ILLUSTRATOR PEOPLE HO
CLIENT EIKON CREATIONS

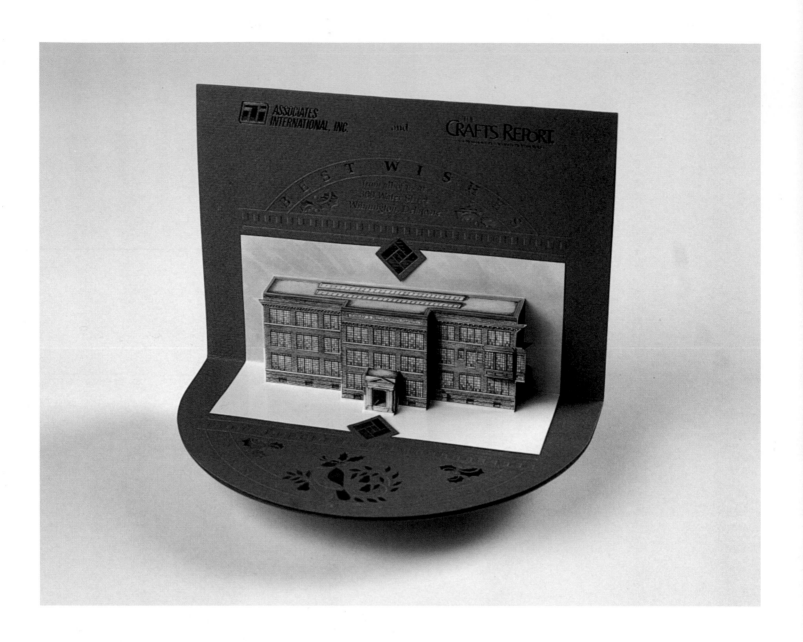

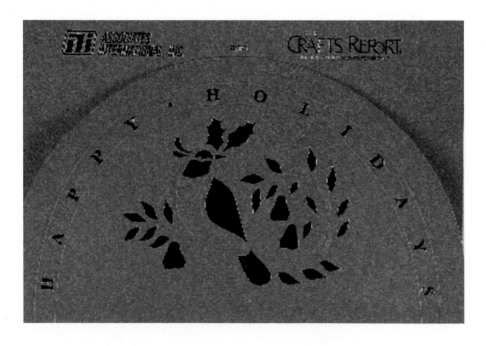

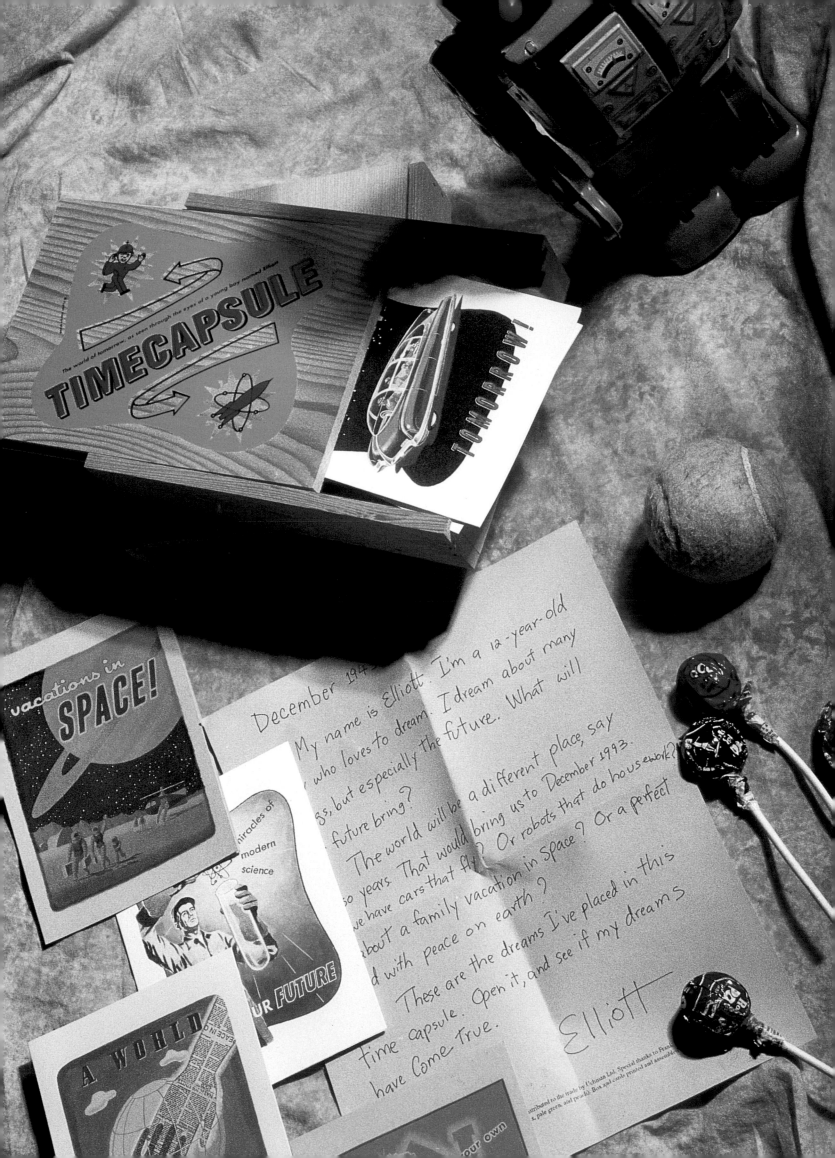

This is a book about Jack.

Jack can't read.

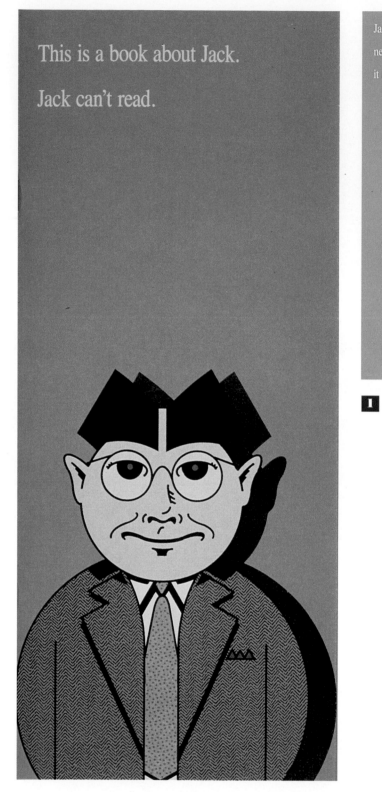

Jack's favorite niece has a brand new book. She wants him to read it to her. He wishes he could.

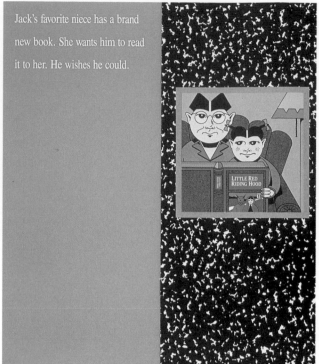

1

Jack goes to lunch. He can't read the menu so he orders the special. Jack's in for a surprise.

1
DESIGN FIRM VAUGHN WEDEEN CREATIVE
ART DIRECTOR/DESIGNER STEVE WEDEEN, RICK VAUGHN,
 GARY CASCIO
ILLUSTRATOR GARY CASCIO
CLIENT GILBERT PAPER

THIS PAPER PROMOTION, ENTITLED "JACK CAN'T READ," WAS DESIGNED TO PUSH THE PRESS CAPABILITIES OF GILBERT OXFORD AS WELL AS EXPRESS CONCERN FOR LITERACY. "IT WORKS AS A PROMOTION, GRABBING THE DESIGN AUDIENCE WITH COLOR AND GRAPHICS," SAYS WEDEEN, ADDING, "IT'S ALSO BEEN WELL RECEIVED BY LITERACY GROUPS."

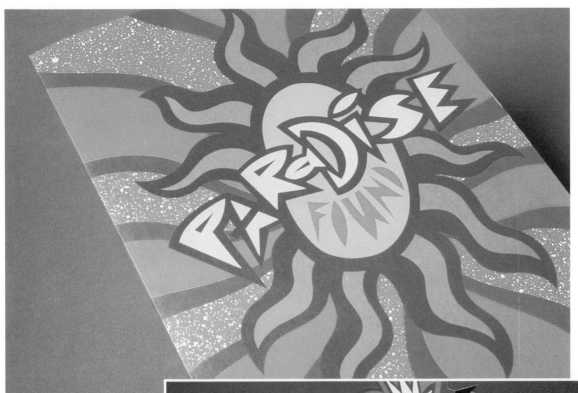

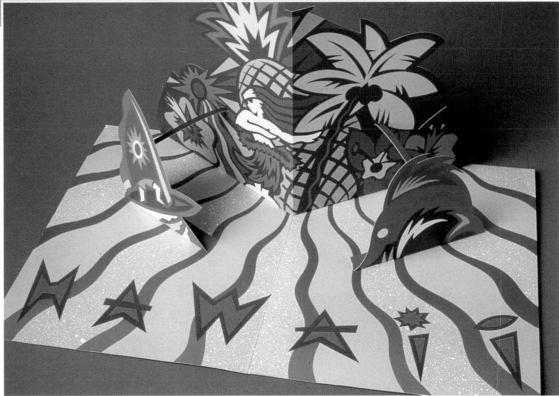

1
DESIGN FIRM SAYLES GRAPHIC DESIGN
ART DIRECTOR/DESIGNER JOHN SAYLES
ILLUSTRATOR JOHN SAYLES
CLIENT ALEXANDER HAMILTON LIFE

*BRIGHTLY COLORED POP-UP GRAPHICS MAKE THIS PROMO-
TIONAL MAILER MEMORABLE AND FUN. IT WAS SUCCESSFUL
IN LURING MEMBERS OF THE CLIENT'S SALES FORCE TO THE
MEETING IT PROMOTED AND WAS KEPT BY MANY RECIPIENTS
WHO ENJOYED ITS ENTERTAINMENT VALUE.*

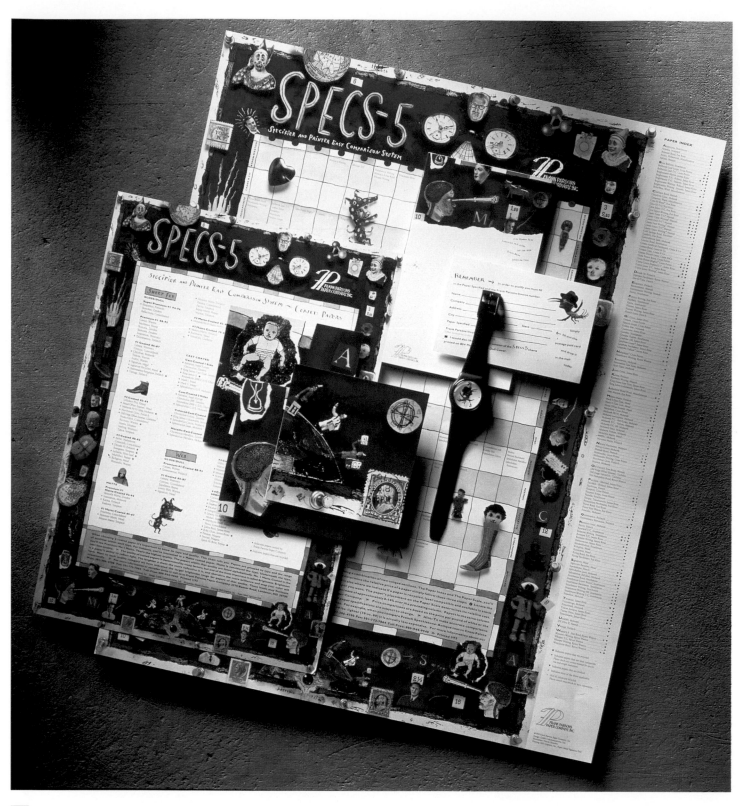

1

DESIGN FIRM	GRAFIK COMMUNICATIONS, LTD.
ART DIRECTOR	JUDY F. KIRPICH
DESIGNER	JULIE SEBASTIANELLI, LYNN UMEMOTO
ILLUSTRATOR	HENRIK DRESCHER
CALLIGRAPHY	HENRIK DRESCHER, MELANIE BASS
CLIENT	FRANK PARSONS PAPER COMPANY, INC.

*THIS COMBINATION POSTER/PAPER SPECIFIER DOES
DOUBLE DUTY AS AN EFFECTIVE PAPER PROMOTION
AND A USEFUL REFERENCE CHART.*

1

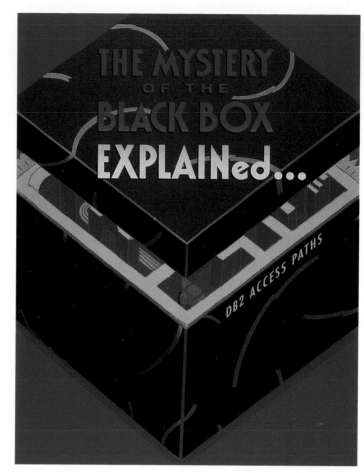

2

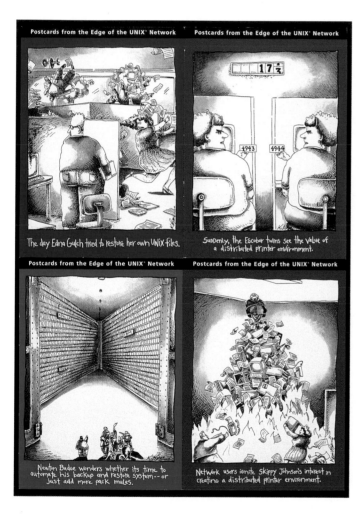

1	
DESIGN FIRM	GRAFIK COMMUNICATIONS, LTD.
DESIGN TEAM MEMBERS	GREGG GLAVIANO, JUDY KIRPICH, SUSAN ENGLISH
ILLUSTRATOR	BILL MAYER
CLIENT	SYSTEMS CENTER, INC.

THIS INTRIGUING POSTCARD DEPICTS A PARTIALLY OPENED BOX CONTAINING A MAZE. "THE CLIENT WANTED TO BUILD A QUALIFIED LIST FOR A NEW PRODUCT WITH THIS MAILING," SAYS GRAFIK COMMUNICATIONS'S CHERYL CLARK. THOSE WHO RESPONDED TO THE POSTCARD MAILING RECEIVED AN INFORMATIONAL FOLLOW-UP MAILING THAT INCLUDED A POSTER OF A MAZE.

2	
DESIGN FIRM	GRAFIK COMMUNICATIONS, LTD.
DESIGN TEAM MEMBERS	RICHARD HAMILTON, JUDY KIRPICH
ILLUSTRATOR	KIM POPE
CLIENT	SYSTEMS CENTER, INC.

A SERIES OF POSTCARDS "FROM THE EDGE OF THE UNIX NETWORK" HINTED AT THE CLIENT'S ABILITY TO SOLVE SYSTEMS PROBLEMS. MANY RECIPIENTS GOT SUCH A KICK OUT OF THE SERIES THEY CONTACTED THE CLIENT REQUESTING ADDITIONAL CARDS TO SHARE WITH INDUSTRY COLLEAGUES.

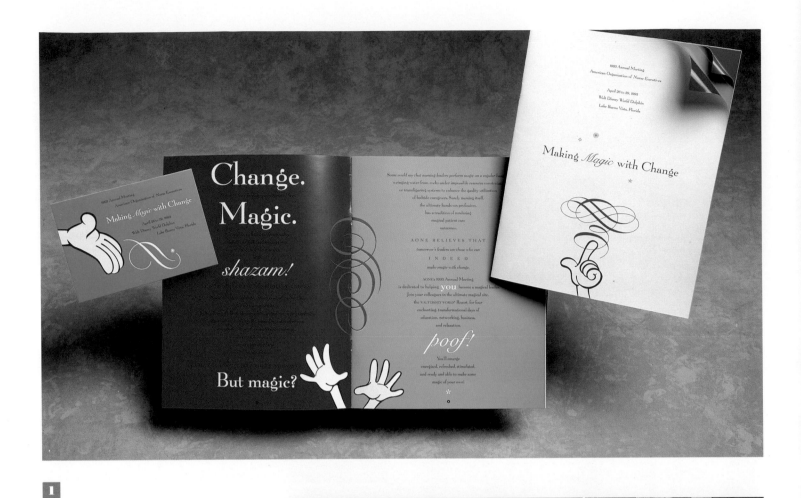

1

2

1

DESIGN FIRM MARK OLDACH DESIGN
ART DIRECTOR/DESIGNER MARK OLDACH
ILLUSTRATOR MARK OLDACH
CLIENT AMERICAN ORGANIZATION
OF NURSE EXECUTIVES

PROMOTING A PROFESSIONAL MEETING AT A CARTOON THEME PARK REQUIRED ARTFULLY INTEGRATING VISUAL ELEMENTS THAT REPRESENTED BOTH. ACCORDING TO DESIGNER MARK OLDACH, THIS PIECE ATTRACTED MORE ATTENDEES THAN THE CONFERENCE COULD ACCOMMODATE.

2

DESIGN FIRM VAUGHN WEDEEN CREATIVE
ART DIRECTOR/DESIGNER RICK VAUGHN
ILLUSTRATOR KEVIN TOLMAN, CHIP WYLER,
RICK VAUGHN
CLIENT U.S. WEST COMMUNICATIONS

THIS BROCHURE WITH A FUTURISTIC THEME DREW MEMBERS OF U.S. WEST'S SALES FORCE TO AN ANNUAL MEETING. ITS CORRUGATED SURFACE ENABLED VAUGHN WEDEEN TO ATTACH AN ASSORTMENT OF ITEMS TO ITS PAGES, PROMPTING RECIPIENTS TO BROWSE THROUGH THE BROCHURE TO DISCOVER THE SURPRISES WITHIN.

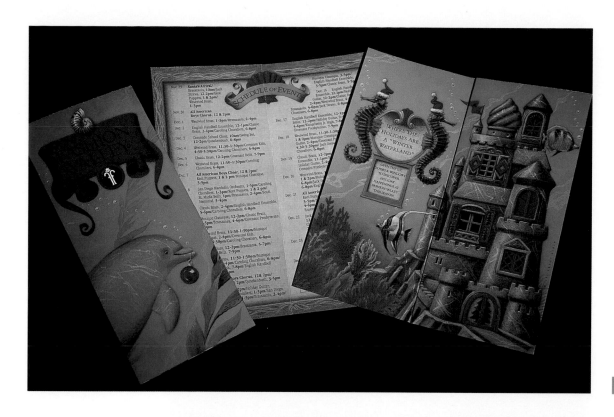

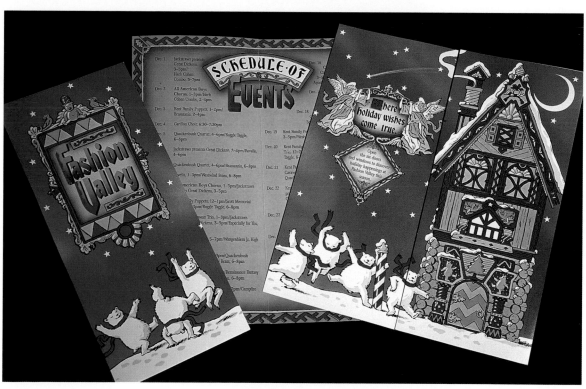

1
DESIGN FIRM TRACY SABIN, ILLUSTRATION & DESIGN
ART DIRECTOR MARILEE BANKERT
DESIGNER TRACY SAGIN
ILLUSTRATOR TRACY SABIN
CLIENT FASHION VALLEY

HOLIDAY HAPPENINGS AT A SHOPPING CENTER WERE PRO-
MOTED WITH PROMOTIONAL FLYERS CARRYING COLORFUL
ILLUSTRATIONS. THE FIRST MAILER WAS SO SUCCESSFUL
IN ATTRACTING ATTENTION, THE CLIENT COMMISSIONED A
SIMILAR PIECE THE FOLLOWING YEAR.

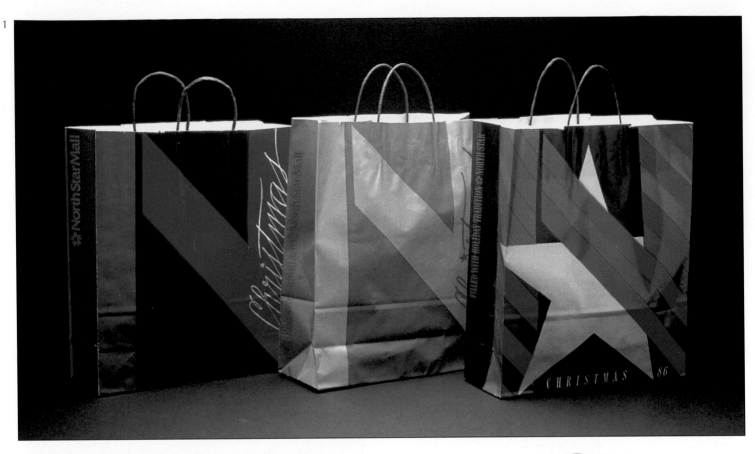

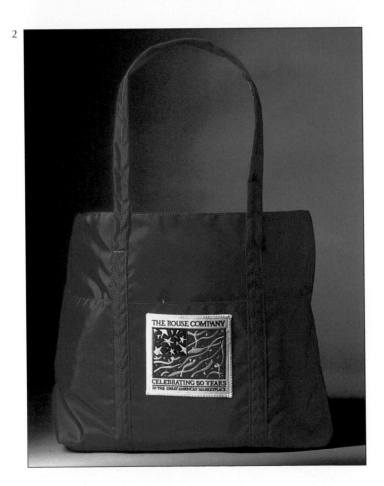

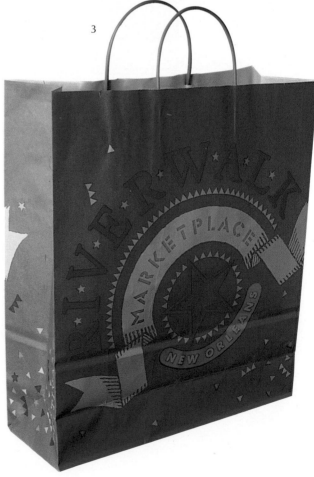

1		2		3	
DESIGN FIRM	SULLIVANPERKINS	DESIGN FIRM	SULLIVANPERKINS	DESIGN FIRM	SULLIVANPERKINS
ART DIRECTOR	RON SULLIVAN	ART DIRECTOR	RON SULLIVAN	ART DIRECTOR	RON SULLIVAN
DESIGNER	LINDA HELTON/RON SULLIVAN	DESIGNER	CLARK RICHARDSON	DESIGNER	ART GARCIA
ILLUSTRATOR/ARTIST	LINDA HELTON/RON SULLIVAN	ILLUSTRATOR/ARTIST	CLARK RICHARDSON	ILLUSTRATOR/ARTIST	ART GARCIA
CLIENT/STORE	THE ROUSE COMPANY	CLIENT/STORE	THE ROUSE COMPANY	CLIENT/STORE	THE ROUSE COMPANY
NUMBER OF COLORS	4	NUMBER OF COLORS	4	NUMBER OF COLORS	6

1

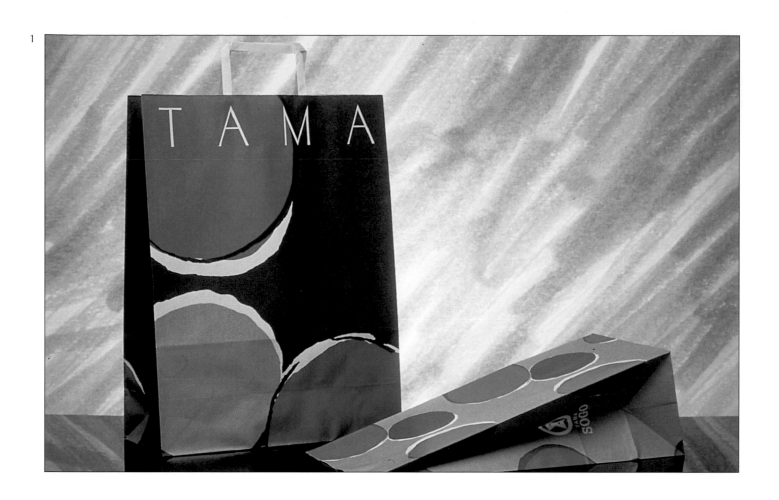

2

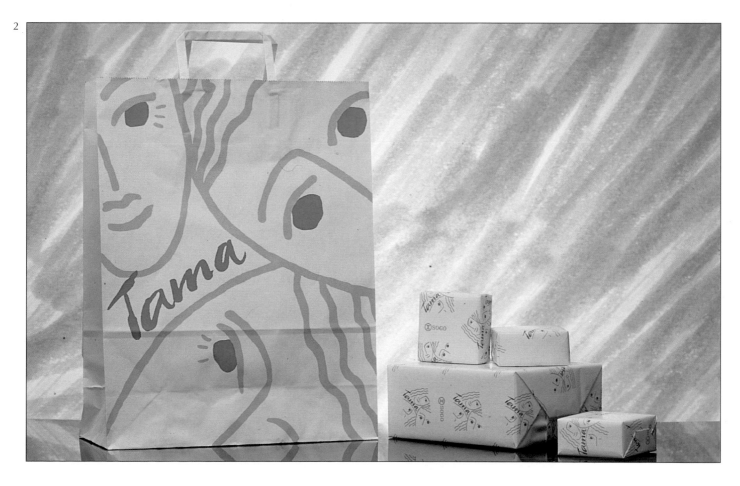

	1		2
DESIGN FIRM	CARRE NOIR	DESIGN FIRM	CARRE NOIR
ILLUSTRATOR/ARTIST	MRS. BÉATRICE MARIOTTI	ILLUSTRATOR/ARTIST	MRS. BÉATRICE MARIOTTI
CLIENT/STORE	TAMA SOGO (JAPAN)	CLIENT/STORE	TAMA SOGO (JAPAN)
NUMBER OF COLORS	2	NUMBER OF COLORS	2

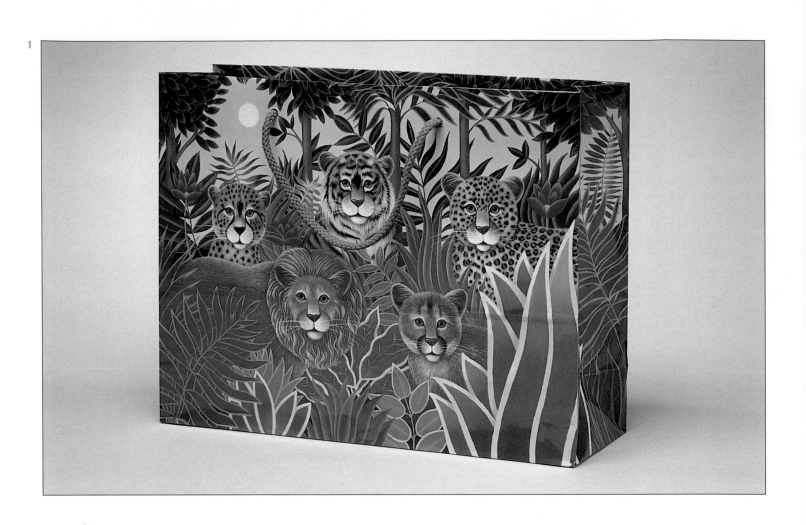

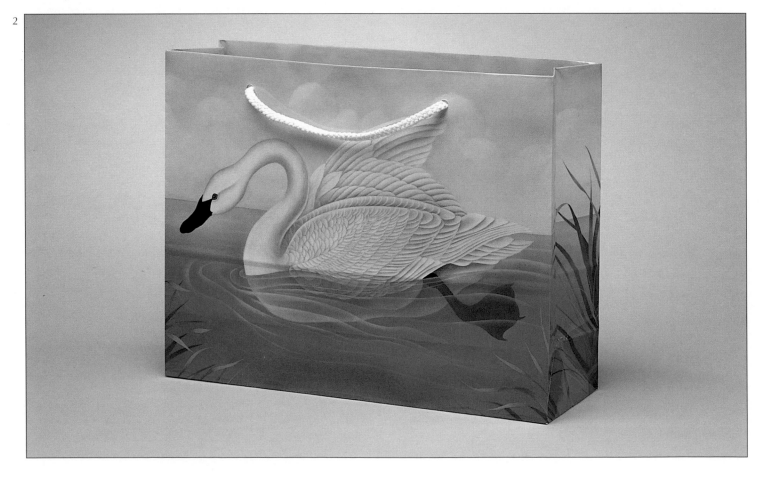

	1			2
ART DIRECTOR	LINDA DeVITO SOLTIS		ART DIRECTOR	LINDA DeVITO SOLTIS
ILLUSTRATOR/ARTIST	LINDA DeVITO SOLTIS		ILLUSTRATOR/ARTIST	LINDA DeVITO SOLTIS
CLIENT/STORE	THE STEPHEN LAWRENCE COMPANY		CLIENT/STORE	THE STEPHEN LAWRENCE COMPANY

1

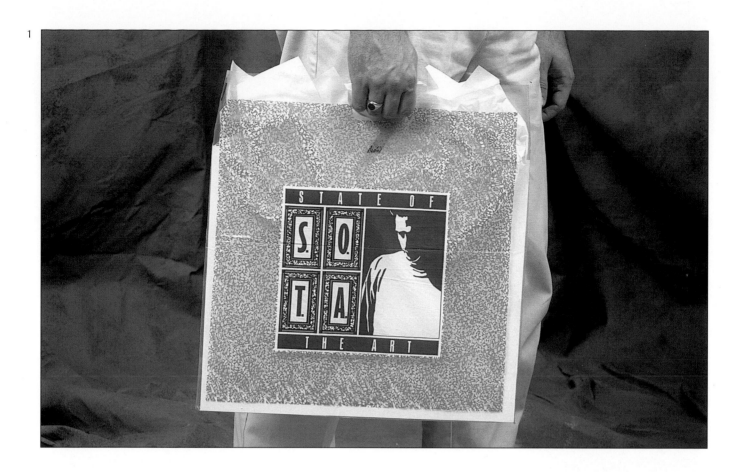

2

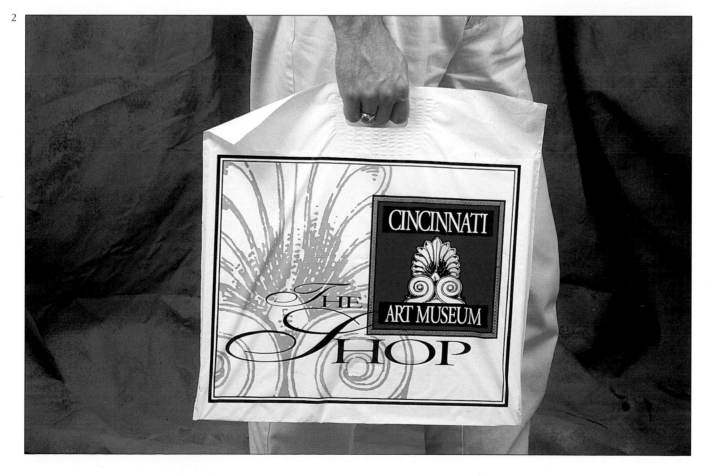

1		2	
DESIGN FIRM	MARSH, INC.	DESIGN FIRM	MARSH, INC.
ART DIRECTOR	GREG CONYERS	ART DIRECTOR	GREG CONYERS
DESIGNER	GREG CONYERS	DESIGNER	GREG CONYERS
ILLUSTRATOR/ARTIST	GREG CONYERS	ILLUSTRATOR/ARTIST	GREG CONYERS
CLIENT/STORE	STATE OF THE ART MEN'S STORE	CLIENT/STORE	CINCINNATI ART MUSEUM
NUMBER OF COLORS	3	NUMBER OF COLORS	3

1

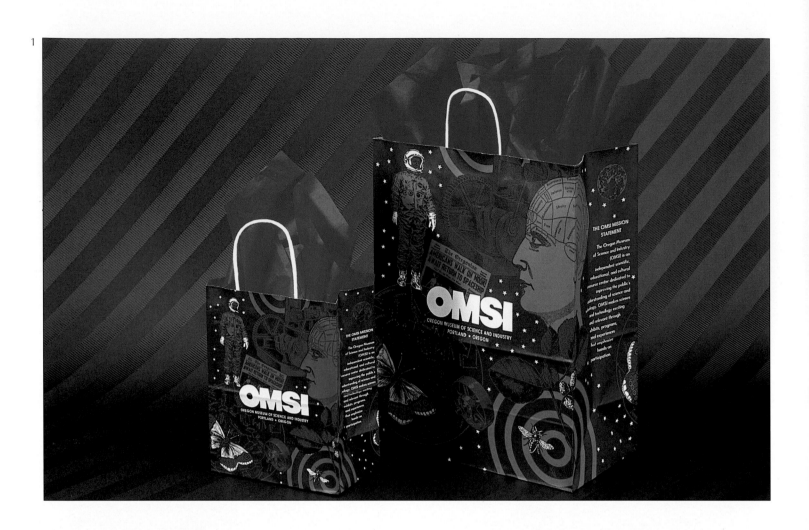

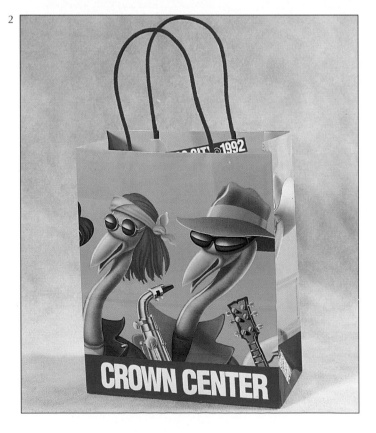

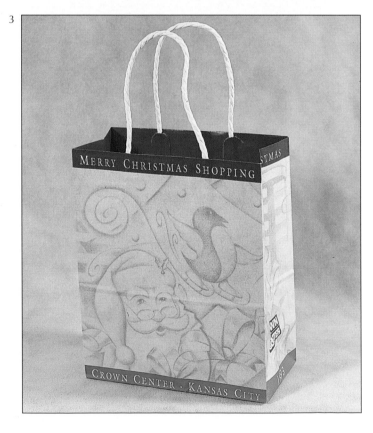

1	
DESIGN FIRM/MANUFACTURER	BONITA PIONEER
ART DIRECTOR	JIM PARKER
DESIGNER	JODI SCHWARTZ
ILLUSTRATOR/ARTIST	JODI SCHWARTZ
CLIENT/STORE	OMSI
NUMBER OF COLORS	3

2	
DESIGN FIRM	MULLER + COMPANY
ART DIRECTOR	JOHN MULLER
DESIGNER	JOHN MULLER
ILLUSTRATOR/ARTIST	MARTY ROPER
CLIENT/STORE	CROWN CENTER
NUMBER OF COLORS	4

3	
DESIGN FIRM	MULLER + COMPANY
ART DIRECTOR	JOHN MULLER
DESIGNER	SUSAN WILSON
ILLUSTRATOR/ARTIST	MIKE WEAVER
CLIENT/STORE	CROWN CENTER
NUMBER OF COLORS	3

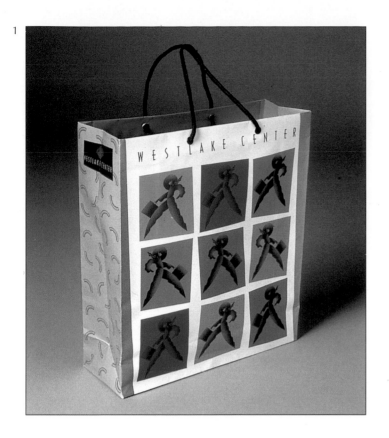

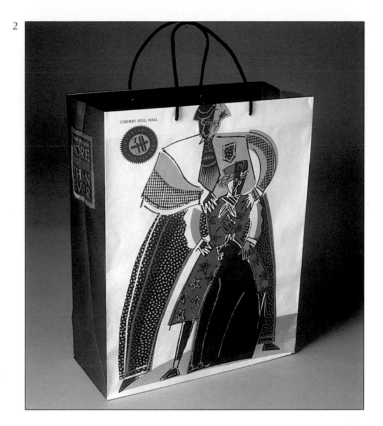

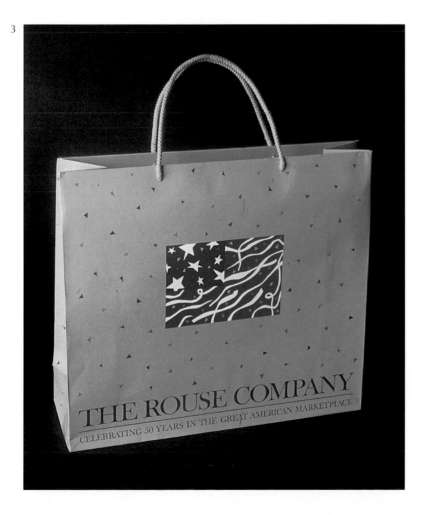

1		2		3	
DESIGN FIRM	SULLIVANPERKINS	DESIGN FIRM	SULLIVANPERKINS	DESIGN FIRM	SULLIVANPERKINS
ART DIRECTOR	RON SULLIVAN	ART DIRECTOR	RON SULLIVAN	ART DIRECTOR	RON SULLIVAN
DESIGNER	JON FLAMING	DESIGNER	JON FLAMING	DESIGNER	CLARK RICHARDSON
ILLUSTRATOR/ARTIST	JON FLAMING	ILLUSTRATOR/ARTIST	JON FLAMING	ILLUSTRATOR/ARTIST	CLARK RICHARDSON
CLIENT/STORE	THE ROUSE COMPANY	CLIENT/STORE	THE ROUSE COMPANY	CLIENT/STORE	THE ROUSE COMPANY
NUMBER OF COLORS	4	NUMBER OF COLORS	4	NUMBER OF COLORS	6

1

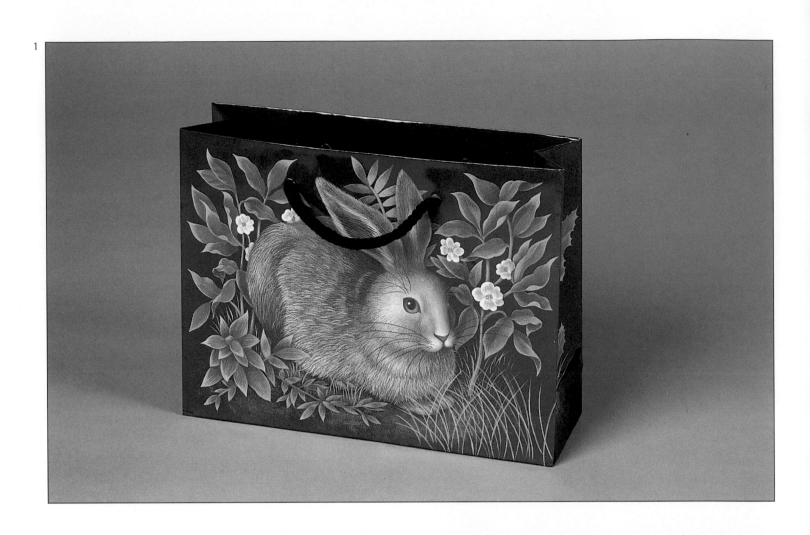

2

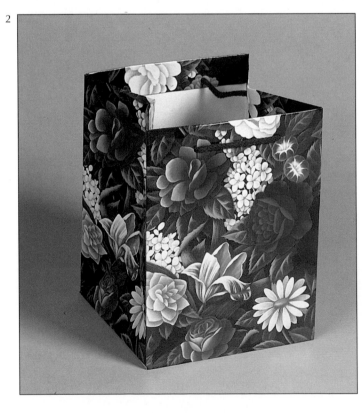

3

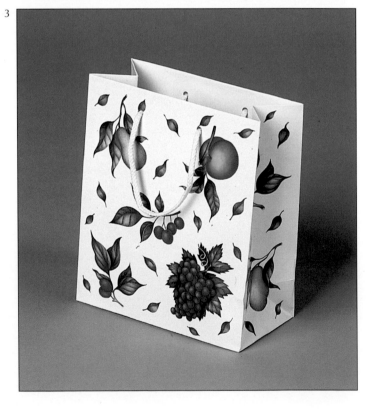

1
ART DIRECTOR PAUL BILSKY
DESIGNER LINDA DEVITO SOLTIS
ILLUSTRATOR/ARTIST LINDA DEVITO SOLTIS
CLIENT/STORE THE STEPHEN LAWRENCE COMPANY

2/3
ART DIRECTOR LINDA DEVITO SOLTIS
DESIGNER LINDA DEVITO SOLTIS
ILLUSTRATOR/ARTIST LINDA DEVITO SOLTIS
CLIENT/STORE THE STEPHEN LAWRENCE COMPANY

1

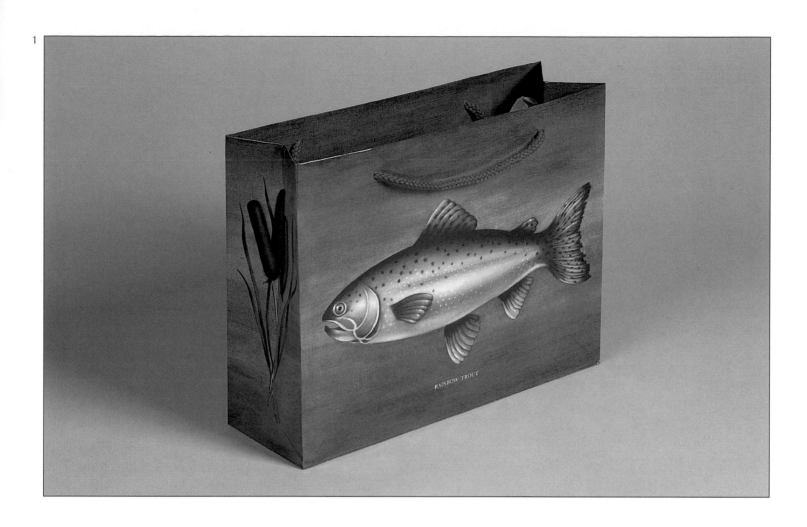

2

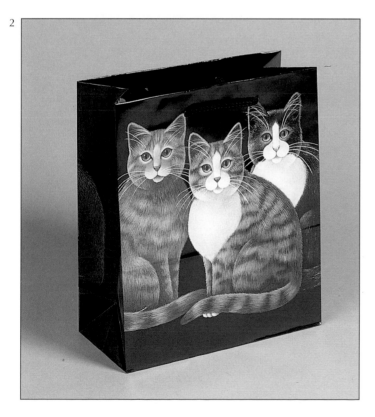

3

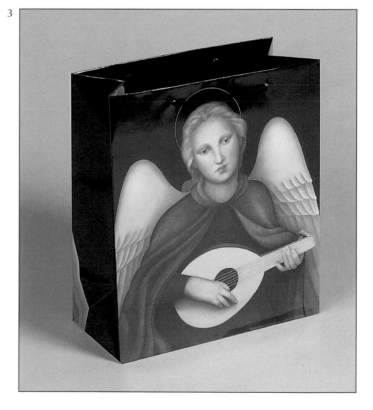

1
ART DIRECTOR PAUL BILSKY
DESIGNER LINDA DEVITO SOLTIS
ILLUSTRATOR/ARTIST LINDA DEVITO SOLTIS
CLIENT/STORE THE STEPHEN LAWRENCE COMPANY

2/3
ART DIRECTOR LINDA DEVITO SOLTIS
DESIGNER LINDA DEVITO SOLTIS
ILLUSTRATOR/ARTIST LINDA DEVITO SOLTIS
CLIENT/STORE THE STEPHEN LAWRENCE COMPANY

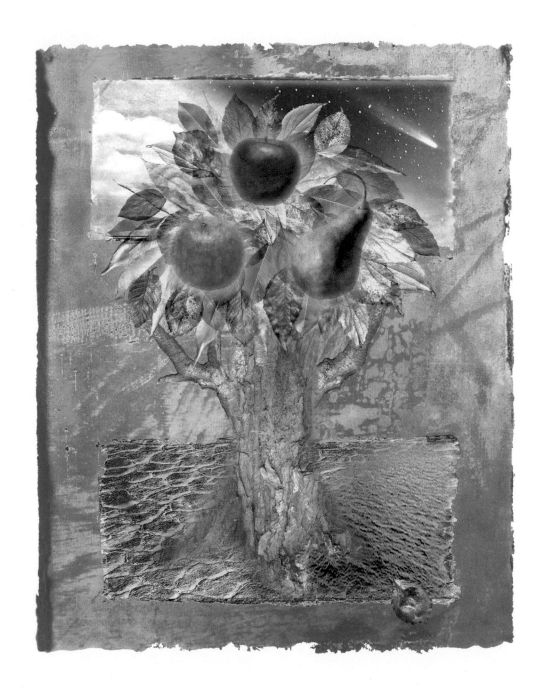

ADVERTISEMENT ILLUSTRATION
DESIGNER DIANE FENSTER
ADVERTISING AGENCY LEVY AND WURZ CHANNEL MARKETING
ART DIRECTOR DAVID LEVY
CLIENT IBM
SOFTWARE ADOBE PHOTOSHOP 3.0
HARDWARE MACINTOSH QUADRA 840 AV

THE LEAVES IN THIS DESIGN WERE ACTUAL AUTUMN LEAVES PLACED ON THE SCANNER AND ARRANGED IN PHOTOSHOP ON THREE SEPARATE LAYERS. BOTH THE BARK AND THE LARGE PIECE OF RUSTED METAL USED FOR THE BACKGROUND WERE ALSO SCANNED DIRECTLY INTO THE COMPUTER.

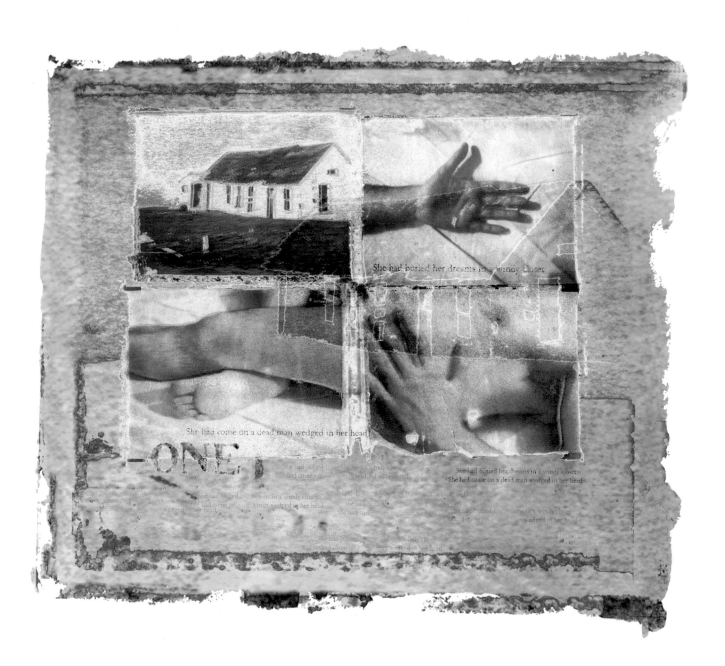

FINE ART SERIES
DESIGNER DIANE FENSTER
SOFTWARE ADOBE PHOTOSHOP 3.0
HARDWARE MACINTOSH QUADRA 840 AV

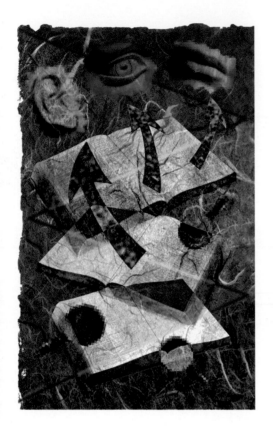

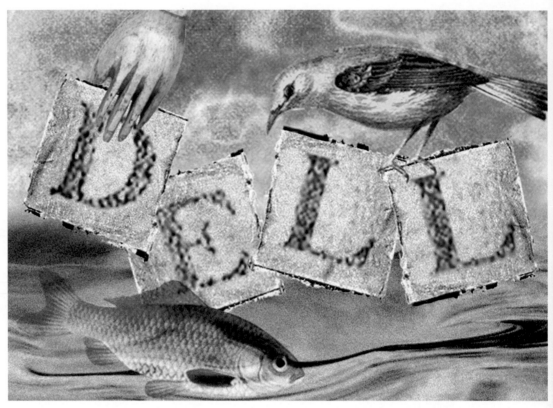

ADVERTISEMENT ILLUSTRATION
DESIGNER DIANE FENSTER
AD AGENCY GOLDBERG MOSER O'NEILL
ART DIRECTOR MIKE MOSER
CLIENT DELL COMPUTERS
SOFTWARE ADOBE PHOTOSHOP 3.0,
 ADOBE DIMENSIONS 2.0,
 KAI'S POWER TOOLS 2.0
HARDWARE MACINTOSH QUADRA 840 AV

SPHERES IN THE IMAGE WERE CREATED BY PLACING A LETTER ON A PATTERN BACKGROUND IN PHOTOSHOP, USING "MARQUEE" TO SELECT A CIRCULAR AREA, AND THEN APPLYING KAI'S FILTER "GLASS LENS SOFT." TYPE WAS CREATED IN DIMENSIONS, AND THE TEXTURE WAS APPLIED USING BOTH PHOTOSHOP AND KAI'S TEXTURE EXPLORER.

MAGAZINE COVER
DESIGNER DIANE FENSTER
CLIENT APPLE
SOFTWARE ADOBE PHOTOSHOP 3.0
HARDWARE MACINTOSH QUADRA 840 AV

THE BACKGROUND WAS TAKEN FROM A SCAN OF RICE PAPER. THE ZIG-ZAG LINE WAS DRAWN WITH THE "PATH" TOOL AND THEN STROKED USING "DISSOLVE" MODE. THE INTERESTING COLOR INTERPLAYS WERE A RESULT OF PLACING OBJECTS ON LAYERS ASSIGNED TO THE "DIFFERENCE" MODE.

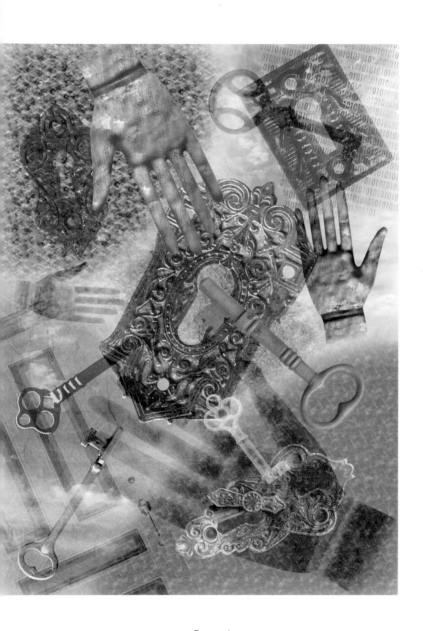

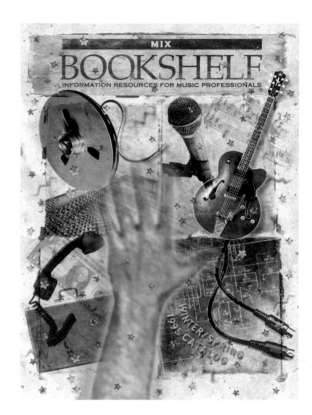

FEATURE ILLUSTRATION
DESIGNER DIANE FENSTER
ART DIRECTOR BRIAN DAY
CLIENT ZIFF DAVIS, GERMANY
SOFTWARE ADOBE PHOTOSHOP 3.0,
SPECULAR TEXTURESCAPE
HARDWARE MACINTOSH QUADRA 840 AV

*ALL OF THE THREE-DIMENSIONAL OBJECTS, SUCH AS THE HAND,
KEYS, AND KEYHOLES, WERE PLACED DIRECTLY ON A SCANNER
AND MANIPULATED IN PHOTOSHOP.*

CATALOG COVER
DESIGNER DIANE FENSTER
ART DIRECTOR MICHAEL ZIPKIN (CARDINAL MUSIC
PUBLISHING)
CLIENT CARDINAL MUSIC PUBLISHING
SOFTWARE ADOBE PHOTOSHOP 3.0, ALDUS FREEHAND
HARDWARE MACINTOSH QUADRA 840 AV

*FOR THIS COVER, THE DESIGNER USED BLACK AND WHITE AND COLOR
SCANNED PHOTOS, XEROXES, SCHEMATICS, AND PHOTO CD IMAGES.
THE HAND IMAGE WAS A FRAME FROM A VIDEO, AND THE MASTHEAD WAS
PROVIDED AS A FREEHAND EPS. THE COMPILED DESIGN WAS RASTERIZED
IN PHOTOSHOP.*